IMAGES
of America

THE CARL SANDBURG HOME
CONNEMARA

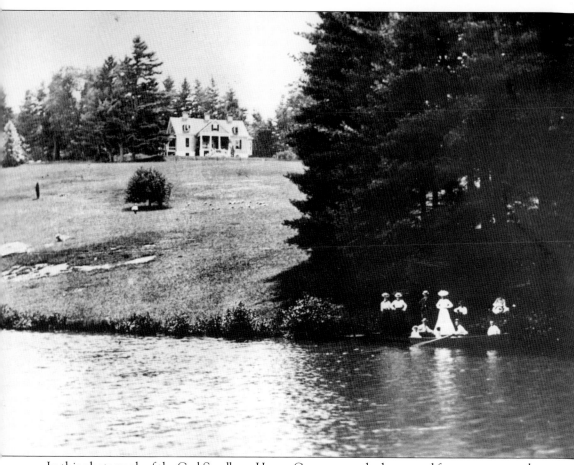

In this photograph of the Carl Sandburg Home, Connemara, the house and front pasture can be seen as they looked about 1900. Christopher Gustavus Memminger built the house in 1838 and called it Rock Hill. The front lake, seen here, was created in the 1850s by damming a rushing stream. A row boat was kept by the lake for impromptu outings during the Smyth era. (Courtesy of the Carl Sandburg Home, NHS.)

ON THE COVER: Taken in June 1946 by well-known photographer June Glenn Jr., this image offers an excellent view of the main house at Connemara a year after the Sandburgs purchased the estate in Flat Rock, North Carolina. Pulitzer Prize–winning poet and author Carl Sandburg is shown standing in the front drive. (Courtesy of June Glenn Jr. and the Carl Sandburg Home, NHS.)

IMAGES
of America

THE CARL SANDBURG HOME CONNEMARA

Galen Reuther

ARCADIA
PUBLISHING

Published by Arcadia Publishing
Charleston SC, Chicago IL, Portsmouth NH, San Francisco CA

Printed in the United States of America

Library of Congress Catalog Card Number: 2006922716

For all general information contact Arcadia Publishing at:
Telephone 843-853-2070
Fax 843-853-0044
E-mail sales@arcadiapublishing.com
For customer service and orders:
Toll-Free 1-888-313-2665

Visit us on the Internet at www.arcadiapublishing.com

This book is dedicated to the volunteers, the Friends of Carl Sandburg at Connemara, and the National Park Service employees who so diligently work to preserve this historic property and the legacy of Carl Sandburg.

CONTENTS

ACKNOWLEDGMENTS

My sincere gratitude goes to Lynn White Savage, museum curator at the Carl Sandburg Home. She was more than generous with her time, advice, and knowledge. Without her help, this book could not have been written. Special thanks go to Paula Steichen Polega, Carl and Lilian Sandburg's granddaughter, who not only gave permission to use her family photographs, but she gave me invaluable advice on accuracy of accompanying information. Thank you so much to Julianne K. Heggoy, great-great-grandchild of Capt. Ellison Adger Smyth and to William McKay, great-grandson of Captain Smyth, who, in addition to sharing photographs, shared with me their family history.

A great many photographs in this book were taken by well-known North Carolina photographer June Glenn Jr. Glenn started working in photography in 1936, and by 1943, he was a full-time reporter/photographer at the *Asheville Citizen-Times*. His photographs have been published in many national publications, and he is a charter and life member of the National Press Photographers Association. Among his many awards are the Joseph Costa Award; Kenneth McLaughlin Award; NPPA Citation; President's Medals in 1960, 1973, and 1986; and the Burt Williams Award for 40 years in news photography. In 1946, Glenn visited Carl Sandburg at Connemara for a Sunday pictorial spread in the *Asheville Citizen-Times*. Sandburg liked Glenn's work, and the two became friends. Glenn visited Sandburg every year around Sandburg's birthday and ultimately photographed his funeral. I am most grateful for Glenn's permission to use his photographs in this book. As with all material included in this publication, his photographs cannot be reproduced. All photographs without a source listed are from my collection.

I also wish to thank my editors at Arcadia Publishing for their guidance and gentle prodding, Maggie Bullwinkel and Adam Latham, whose idea it was to write a book on the Carl Sandburg Home. Thank you to everyone who gave me permission to reproduce their photographs and to my husband, Lee, for his encouragement on all my projects.

INTRODUCTION

To appreciate the significance of the Carl Sandburg Home, Connemara, one must go back to the early 1800s, when an elite group of Lowcountry planters, businessmen, and statesmen discovered the pleasures of summers high in the Blue Ridge Mountains. This scenic area with cloud-piercing evergreens, abundant wildlife, and pure air and water took its name from an immense expanse of exposed rock that was the summer campground of the Cherokee. Portions of the rock can still be seen at the Flat Rock Playhouse and at the entry to the Flat Rock Village Hall.

In 1783, North Carolina ceded all land claimed by the Cherokee to the federal government, and shortly afterward, land grants were issued to pioneers who established the first inns, taverns, mills, and farms. It was not until the first real road, the Old Buncombe Turnpike, was completed in 1827 that travel by stagecoach became possible. It was at this time that the face of Flat Rock would begin to be irrevocably changed. The South Carolina rice fields had changed from water reserves to tidal irrigation, resulting in standing water that attracted disease-carrying insects. The first families came not only in search of a cool and healthy summer climate, but also to explore possible development of rail lines from the interior to the seacoast.

In 1827, Charles and Susan Baring of Charleston built the first grand estate, Mountain Lodge, and acquired up to 4,000 acres of land. They in turn sold land to friends who followed. The Charlestonians formed their own group and established a lavish lifestyle not seen today. It was into this group, in this village called "The Little Charleston of the Mountains," that Christopher Gustavus Memminger would arrive in 1836. He bought his first parcel of land from Charles Baring on which to build a farm. He named his farm Rock Hill and would come to call it "my earthly paradise." So begins the story of a very special place, the Carl Sandburg Home, Connemara.

One

EARLY FLAT ROCK
The Memminger Era

All owners of Rock Hill, now the Carl Sandburg Home, National Historic Site, were important people of their time. C. G. Memminger, born in Germany and orphaned as a child in Charleston, would become one of the South's great attorneys and advocates of equal education. He supported the Union when winds of a Civil War began to blow but gradually realized secession was inevitable. He would serve as first secretary of the Confederate treasury under Pres. Jefferson Davis.

Memminger, a man of slight build and fragile health, fell in love with Flat Rock, and by all accounts, his time here was cherished. Here he could farm and garden and be among friends. A noted architect of the time, Prussian-born Charles F. Reichardt, was hired to design the Greek Revival–style house. Thanks to Memminger's meticulous notes and account books, we know the timeline for completion of most buildings on the property.

Construction began in the spring of 1838, and that summer, the kitchen house and stable were constructed. By 1839, the main house was complete, and the Memmingers spent their first summer in Flat Rock. The cook's house (now the wash house/chicken house) was erected c. 1841, and in 1843, a wagon shed was built. Around 1845, Memminger purchased land for his Valley Farm, where he planted his vegetable garden. Valley Farm would become Tranquility, owned by Memminger's youngest son, Edward. About the same time, an icehouse was built, and in 1846–1849, an addition was added to the main house. The servant's quarters (now the Swedish house) were constructed c. 1850. The front lake and dam were completed in 1855. Memminger also kept a record of temperatures at Flat Rock and sent them to the Charleston newspaper so Charlestonians could read how lovely the summers were in Flat Rock.

The Memmingers were in Flat Rock the summer of 1864 and remained for the duration of the Civil War. To fortify the house against intruders and bushwhackers, Memminger removed the front entrance steps (not rebuilt until the Gregg era), the lower floor was fortified with sandbags, and gun ports were cut in the walls of the house. It became a safe haven for villagers and friends who felt threatened. Memminger was at Rock Hill when informed of General Lee's surrender and Sherman's triumph at Bentonville. We owe a debt of gratitude to Memminger for establishing this unsurpassed property and to his family and those who came after for being good stewards of the land. By all accounts, the Carl Sandburg Home is the only grand estate of its era that has not been subdivided.

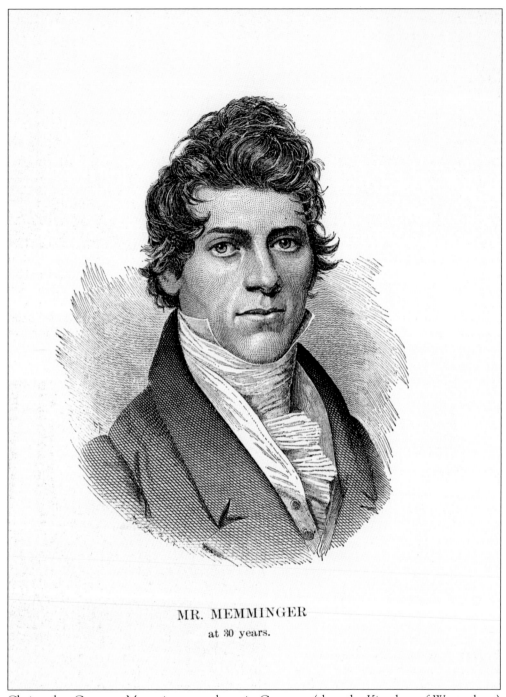

MR. MEMMINGER

at 30 years.

Christopher Gustavus Memminger was born in Germany (then the Kingdom of Wurtenberg) in 1803. He is shown here at the age of 30, just three years prior to his arrival in Flat Rock. Memminger had a brilliant mind. He graduated from South Carolina College (the University of South Carolina) at the age of 16, graduating second in his class. He became a U.S. citizen in 1824 and was admitted to the Bar in 1825. In 1832, he married Mary Withers Wilkinson, the woman he called "the love of my young life," and they had 11 children, 9 of whom reached adulthood.

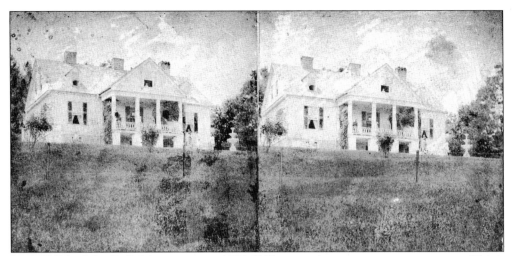

Rock Hill, built by C. G. Memminger in 1837–1838, is seen here in a stereopticon image. This is the only known image of the house from this period. During the Civil War, Memminger and his family lived at Rock Hill. Memminger suggested to Confederate president Jefferson Davis that he move the capital from Richmond to Flat Rock for safety purposes. President Davis seriously considered the change, but the move was rejected because of inaccessibility. Edward Read Memminger, C. G. Memminger's youngest son, gave this image to Carl Sandburg. (Courtesy of the Carl Sandburg Home, NHS.)

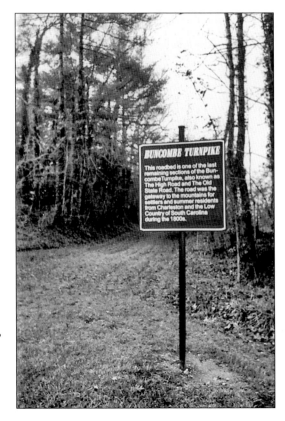

By 1795, there was a very rudimentary wagon road through the Saluda Gap and on through Flat Rock to Tennessee. In 1827, the Buncombe Turnpike was opened, allowing travel by wagon and stagecoach. The last section of this historic road, shown here, can be seen at the Dunroy Subdivision on Rutledge Road in Flat Rock. (Courtesy of Charles Kuykendall.)

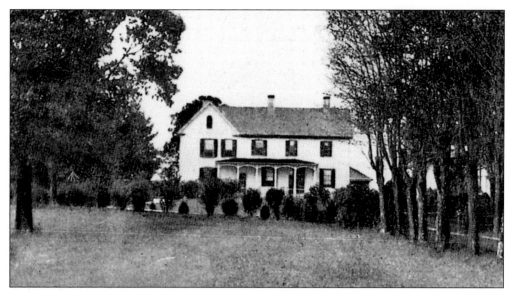

Built by Count Joseph Marie Gabriel Xavier de Choiseul, French consul to Charleston and Savannah, Saluda Cottages stands across Little River Road from Connemara. Count de Choiseul went on to build the castle Chanteloup and sold Saluda Cottages to A. S. Willington of Charleston. On New Year's Day 1850, Memminger bought Saluda Cottages for $4,500, with 250 acres. He and his friend, Andrew Johnstone, laid out Little River Road. Memminger added considerable acreage from Saluda Cottages to his Rock Hill and then sold Saluda Cottages to Rev. Charles Cotesworth Pinckney, whose son later married Memminger's daughter, Lucy. (Courtesy of Historic Flat Rock, Inc.)

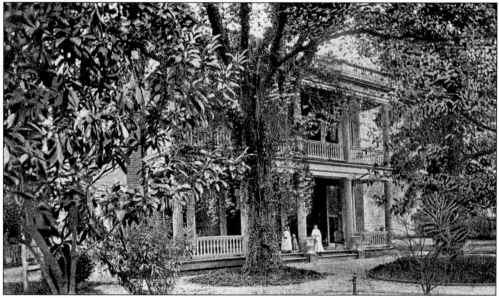

C. G. Memminger's home in Charleston was at the corner of Wentworth and Smith Streets. Seen here in a very early photograph, it was seized by the Union troops during the Civil War and turned into a home for orphaned black children. It was not until 1867 that Memminger's property and right to practice law were returned to him after he was granted a federal pardon. He went on to be a pioneer in the phosphate industry in South Carolina.

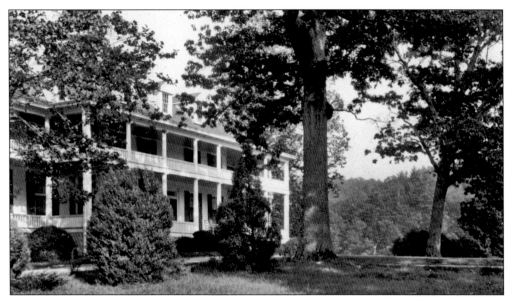

Along with the Baring family came Judge Mitchell King, a statesman, Scottish by birth, who built Argyle in 1830. In addition to the great Argyle, he purchased several thousand acres of land. When Henderson County was created by the legislature in 1838, King donated acreage for the county courthouse. Argyle is the oldest estate in Flat Rock still owned by the original owner's family. (Courtesy of Historic Flat Rock, Inc.)

Mountain Lodge is acknowledged to be the earliest of the grand estates built by the Charlestonians. Erected in 1827 by Charles and Susan Baring with land holdings up to 4,000 acres, Mountain Lodge is still visible at the corner of Rutledge and Trenholm Roads. Many of Baring's friends came to Flat Rock and bought land from them for their own estates. One of these friends was C. G. Memminger, who went on to build Rock Hill. (Courtesy of Historic Flat Rock, Inc.)

In this side view of Tranquility, one sees the many-windowed, tall, bright house with a multitude of porches built by Edward Read Memminger in 1890. Memminger's Tranquility began as Valley Farm, purchased in 1844 by Memminger's father, C. G. Memminger. The property was his vegetable garden. A house on the property was leased to the Hollingsworth family and was the scene of a Civil War event, outlined in the book *Seven Months a Prisoner* by J. V. Hadley. (Courtesy of Historic Flat Rock, Inc., and Dr. and Mrs. Malcolm McDonald.)

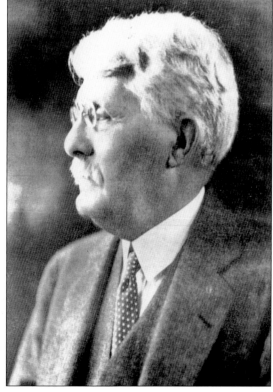

Edward Read Memminger was born in Charleston in 1856, the 11th child of C. G. Memminger. Edward Read became an attorney with a practice in Charleston, but ill health forced him to retire to his beloved Flat Rock. He turned his interest to botany, an interest that may have been inherited from his father. From the 1880s, Memminger collected botanic specimens and went on to increase his collection after building Tranquility. Upon his death, 1,000 rare botanic specimens were donated to University of North Carolina. (Courtesy of the Carl Sandburg Home, NHS.)

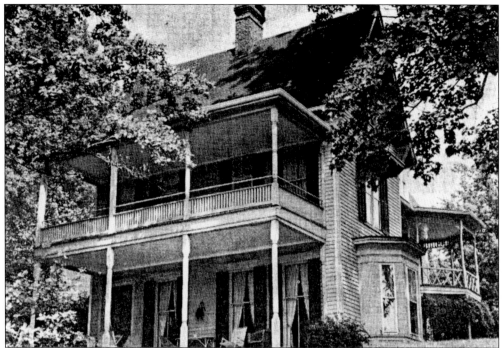

Tranquility, built in 1890 by Edward Read Memminger, was built as a gift to his bride. The house is seen in these two Victorian-era photographs: the exterior is shown above, and the front parlor, to the right of the front door as you enter, is seen below. Edward Read spent his youth at his family's home, Rock Hill, just a mile or two away. He is buried at St. John in the Wilderness churchyard facing Rock Hill, as he had requested. Tranquility was inherited by Memminger's daughter, Marjorie Norment. After her death, her husband, Walter, lived there until the early 1900s.

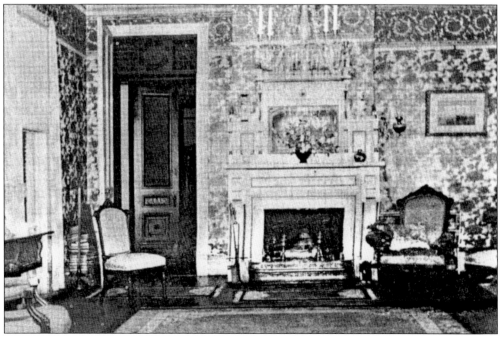

Seen in these two photographs is the Flat Rock Inn. The house was built in 1888 by Robert Withers Memminger as a summer home. Memminger was a minister in Charleston and a son of C. G. Memminger. Family members etched their names in window glass in the kitchen building and in one of the front rooms. Robert Withers Memminger died in 1901. His widow, Susan Mazyck, kept the house until 1911, when she sold it to Thomas Grimshawe and his wife, Elizabeth. They named it Five Oaks and used it as a year-round residence until 1930, when they gave it to their daughter, Greta G. King, and her husband, Campbell King. During the Depression, the house was a boarding house. At first, it was for women only, and later men lived there as well. Men lived on the second floor and had to enter by an outside staircase so as not to go through the ladies' quarters. (Courtesy of Dennis and Sandy Page.)

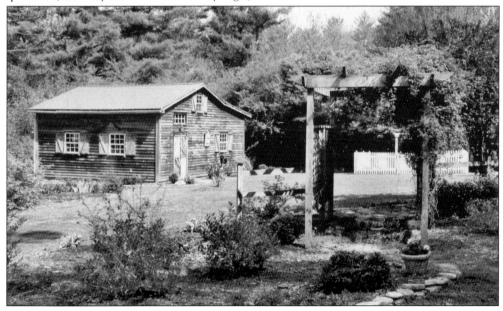

The drawing room and the dining room of the Flat Rock Inn, built by Robert Withers Memminger, are seen here in their beautifully restored state. Many original features have been preserved throughout the house. When Campbell and Greta King owned the property, Mr. King grew hot peppers and made hot pepper sauce that he bottled and sold. When the present owners renovated the property, they rebuilt the front stairs to match early photographs. The kitchen building, once separated, was joined to the main house in years past. The house reopened in 1993 as the Flat Rock Inn, owned by Dennis and Sandy Page. (Courtesy of Dennis and Sandy Page.)

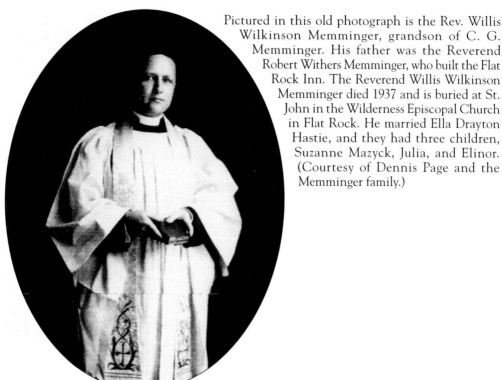

Pictured in this old photograph is the Rev. Willis Wilkinson Memminger, grandson of C. G. Memminger. His father was the Reverend Robert Withers Memminger, who built the Flat Rock Inn. The Reverend Willis Wilkinson Memminger died 1937 and is buried at St. John in the Wilderness Episcopal Church in Flat Rock. He married Ella Drayton Hastie, and they had three children, Suzanne Mazyck, Julia, and Elinor. (Courtesy of Dennis Page and the Memminger family.)

Although this is a recent pathway at Connemara, it is typical of old Flat Rock walks. The Reverend John Grimke Drayton, longtime rector at St. John in the Wilderness Episcopal Church, created a path from his home, Ravenswood, to the church. It wound through many properties, including Rock Hill and Saluda Cottages. It was called the Jerusalem Path. (Courtesy of Alice Soder.)

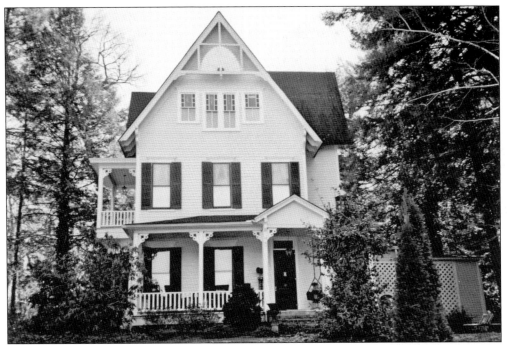

Enchantment, originally called Richmond Hill, was built in 1887 by Dr. Allard Belin Memminger II, son of C. G. Memminger. It is a tall stately house with a Gothic influence. Dr. Memminger built this house after studying medicine in his father's native Germany. The doctor tended patients in his home office, now a library, for many years. Mary Middleton Pinckney Lee, Dr. Memminger's niece and wife of Confederate general Robert E. Lee's grandson, later owned the house. In 1908, Dr. Memminger was dean of the College of Medicine MUSC, then called the Medical College of the State of South Carolina. (Courtesy of Historic Flat Rock, Inc.)

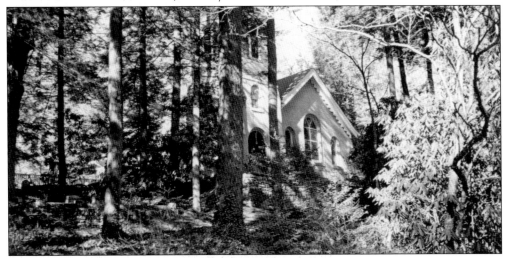

St. John in the Wilderness Episcopal Church was built as a private chapel by Charles and Susan Baring. Their house, Mountain Lodge, built in 1827, is acknowledged to be the earliest of the grand houses built by people from the Lowcountry who made Flat Rock an elite summer colony. The original chapel burned in an accidental fire, and the church was rebuilt on its present site. The church was consecrated in 1836. It is the oldest Episcopal church in Western North Carolina.

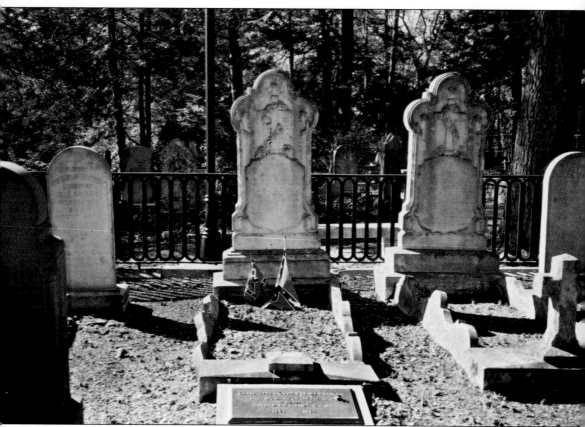

C. G. Memminger, the senior statesman so important to the South, died in Charleston on March 7, 1888. His son Dr. Allard Belin Memminger II was at his side. As requested, the funeral was held at St. Paul's Episcopal Church in Charleston. The service was conducted by his friend (and Flat Rock neighbor) Rev. Charles Cotesworth Pinckney and the rector of St. Paul's, the Reverend Campbell. After the service, his casket was taken to the Line Street station of the South Carolina Railroad and brought to Flat Rock for burial beside his first wife, Mary Withers Wilkinson, at St. John in the Wilderness churchyard. His family traveled in a separate railroad car. In this photograph, we see the Memminger grave site.

Two

THE SMYTH ERA

A year after C. G. Memminger's death, Rock Hill was purchased, fully furnished, in trust for Mary Fleming Gregg, wife of William Gregg Jr., son of William Gregg, the "father of Southern cotton manufacturing." Gregg Sr.'s Graniteville, Georgia, mills were the best in the nation. Gregg Jr. served as department head and treasurer at his father's mill. Rock Hill was their summer home for 10 years, and according to a recent Historic Structure Report, they made several improvements to the house. In addition to replacing the front steps, they installed a bay window and period mantels. William Gregg Jr. died in 1895 at the age of 61, but his widow kept the estate until 1900.

Rock Hill was purchased by J. Adger Smyth and Augustine T. Smyth in trust for their brother, Capt. Ellison Adger Smyth, the "dean of Southern textile operators." Born Joseph Ellison Adger Smyth in 1847 to an influential Charleston family, he went on to establish himself as the foremost leader of the manufacturing industry. He built Pelzer Mills and served as president of the South Carolina Manufacturing Association. In 1861, too young to enlist, he watched the bombardment of Fort Sumter. He entered the Citadel (the Military College of South Carolina) and, at 16, joined the Confederate army. He came through the conflict, although his parents were told he had been killed on the battlefield. When the war was over, Charleston became a center of lawlessness. Smyth organized the Carolina Rifle Club and became president of the Washington Artillery Rifle Club, where Gov. Wade Hampton appointed him captain. Smyth retained this title through life.

In 1900, the Smyths acquired Rock Hill and changed the name of the property to Connemara after one of Ireland's most beautiful regions. On a trip to Ireland, the captain's wife, Julia Gambrill Smyth, picked sprigs of ivy and brought them back on board the ship stuck in a potato for moisture. When she got home, she planted her "bits of Ireland," and today Mrs. Smyth's ivy can still be seen throughout Connemara. The captain ran Connemara as a farm, and for 25 years, the family spent joyous summers there, surrounded by grandchildren and great-grandchildren. In 1925, they moved to Connemara permanently. The captain opened Balfour Mills in Henderson County and was a great philanthropist in the community.

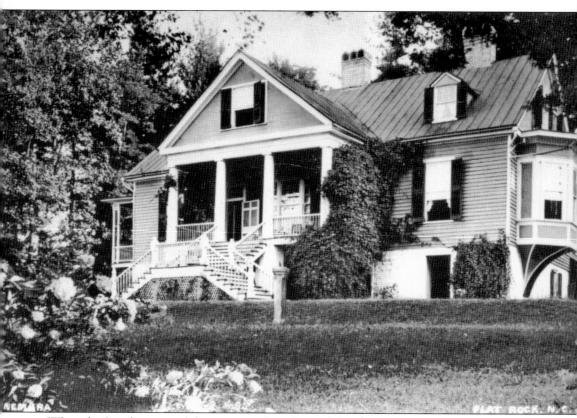

When the Smyths acquired the property, they changed the name from Rock Hill to Connemara because it reminded them of that beautiful place in Ireland. The house was painted green with white trim, as seen here. Some say it stayed this way until after World War I. In 1925, the Smyths moved to Flat Rock full time after renovating the house for year-round living. (Courtesy of Julianne K. Heggoy collection, the Carl Sandburg Home, NHS.)

Seen in this photograph, from left to right, are the three Smyth brothers, James Adger Smyth (who was mayor of Charleston for eight years), Capt. Ellison Adger Smyth, and Augustine T. Smyth (a major in the Confederate army). It was James Adger and Augustine T. Smyth who purchased Rock Hill from William Gregg Jr.'s widow. In 1900, they deeded the property to their brother, Capt. Ellison Adger Smyth. (Courtesy of Julianne K. Heggoy.)

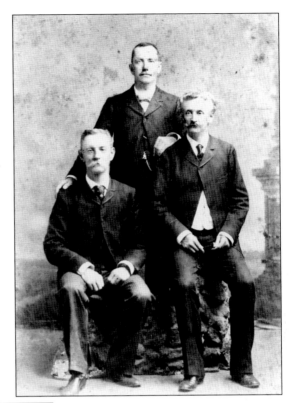

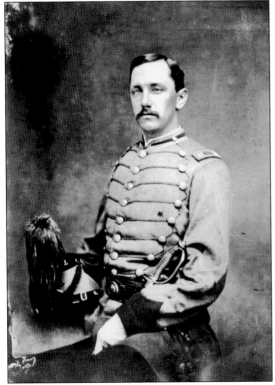

Capt. Ellison Adger Smyth, seen here, was a dashing figure in his uniform as a captain of the Washington Light Artillery in Charleston. After the Civil War ended, there was little money in Charleston. Businesses were closed, and the recently freed plantation workers flocked into the city. The Smyth family home at 18 Meeting Street sustained considerable damage during the war. Captain Smyth joined the Washington Artillery Rifle Club to help keep peace and to protect private properties from vandalism. (Courtesy of Julianne K. Heggoy.)

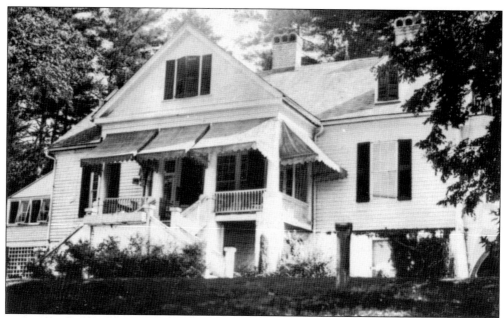

In this wonderful photograph of Connemara, taken probably in 1925 during the Smyth era, we see the house once again painted white with great large awnings around the front porch. The house is wood-framed and has three levels. The walls on the bottom floor are made of stone. The second floor contained the living area, and the third floor was used for bedrooms. Sheep and sometimes cattle were pastured in front of the house to keep growth down. (Courtesy of Julianne K. Heggoy collection, the Carl Sandburg Home, NHS.)

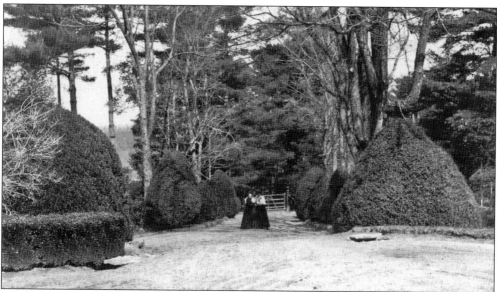

When Memminger built Rock Hill, he had many gardens installed on the grounds, including boxwood gardens. By the Smyth era, these boxwoods had become huge and lush. Here we see three young ladies on April 6, 1901, out for a stroll along an avenue of giant trees and boxwoods. From left to right are Susie Adger Smyth, Olive Hill, and Sadie Smyth. (Courtesy of Julianne K. Heggoy.)

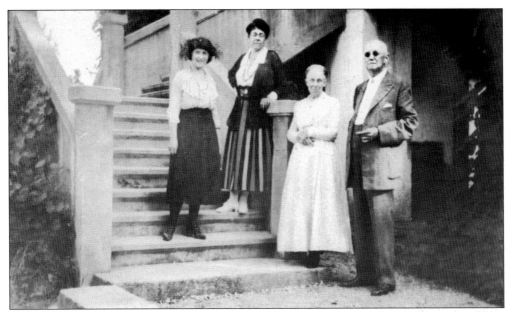

Pictured in 1921 before the Captain and Mrs. Smyth moved full time to Connemara are (from left to right) an unidentified visitor; Margaret Adger Smyth, the captain's oldest child; Julia Gambrill Smyth; and Captain Smyth. Margaret Adger married Foster McKissick, who became very successful in the textile industry in Greenville, South Carolina. She was called "Sis Margaret" by her family. (Courtesy of Julianne K. Heggoy collection, the Carl Sandburg Home, NHS.)

The captain's daughter Sarah Ann (called Sadie by her family) spent much of her leisure time with her best friend, Olive Hill. Sarah (left) and Olive are shown sitting in the east bay window at Connemara on April 6, 1901. (Courtesy of Julianne K. Heggoy collection, the Carl Sandburg Home, NHS.)

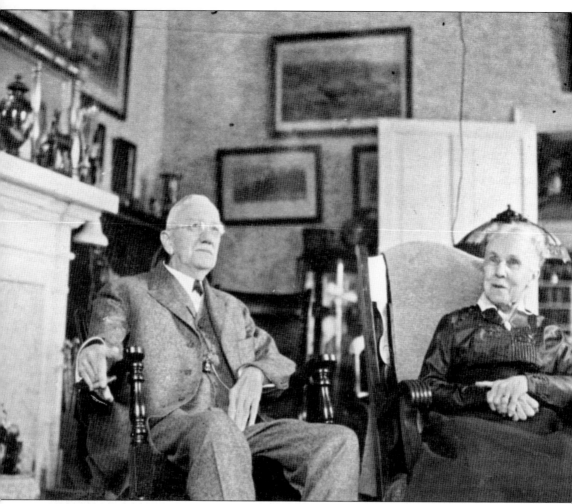

The living room, seen here in the Smyth era, contained comfortable furnishings, framed artwork, and electric lights. The Captain is shown with his ever-present 7-20-24 brand cigar between his long fingers. Behind Mrs. Smith, we can see into the library, where animal heads were mounted over the bookcases. The Captain read constantly. In his library, he had a sign that read, "Books are vaults within whose silent chambers treasures lie." He often told the story of working in his office in the evening when the floor would creak and the door would open, untouched. The Captain would say, "Good evening Mr. Memminger." After the Smyths retired to Connemara, the Captain built Balfour Mills for his son Adger to operate. After Adger's unfortunate early death around 1928, the Captain returned to work at Balfour Mills, located on U.S. 25 a few miles north of Hendersonville, where he worked until he was 93 years old. He was over six feet tall, and he walked every day on his property. (Courtesy of Julianne K. Heggoy collection, the Carl Sandburg Home, NHS.)

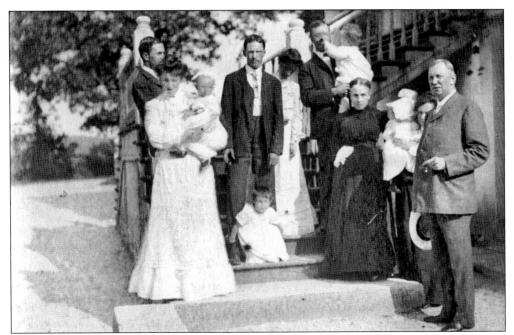

In 1903, the Smyth family gathered on the steps of Connemara for a family photograph. Seen here from left to right are Lewis Du Veaux Blake; his wife, Annie Pierce Smyth Blake, holding their daughter, Julia; James A. Smyth with an unidentified child sitting at his feet; Mary Smyth McKay; A. F. McKissick holding an unidentified child; Julia Gambrill Smyth; Jane Adger Smyth (partially hidden) holding an unidentified child; and Capt. Ellison Adger Smyth. (Courtesy of Julianne K. Heggoy collection, the Carl Sandburg Home, NHS.)

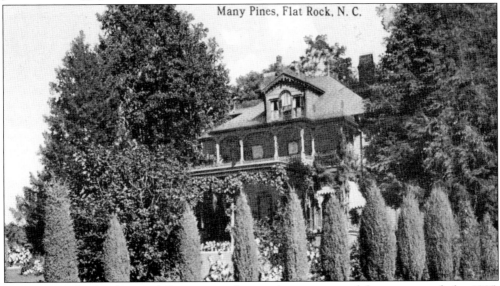

Captain Smyth's family visited Connemara often, in the summers and then year-round after 1925, when the captain made it their permanent home. His brother Augustine purchased Many Pines, an estate that at that time encompassed the Hillandale subdivision. Many Pines, seen here on a postcard dated 1913, is still in the hands of descendants of Augustine T. Smyth. Augustine's son, called Austin, started the preservation of spirituals in Charleston at the Dock Street Theatre.

In April 1901, the year after Captain Smyth acquired Connemara and before the house was painted green, Sarah Smyth and her friend Olive Hill can be seen on the front steps. The family, with their servants and supplies, traveled by train to Spartanburg, then by horse and carriage the rest of the way to Flat Rock. About 1912, touring cars replaced the horses and carriages. Cars were an oddity on country roads and often frightened horses along the way. The cars always traveled in tandem in case of a breakdown. The captain would give out pen knives to little boys and dolls to little girls along the roadside. (Courtesy of Julianne K. Heggoy collection, the Carl Sandburg Home, NHS.)

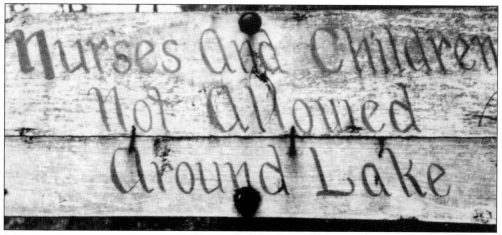

It has long been a rumor that one of the Memminger children may have died in the front lake, but the lake was not built until after the deaths of the Memminger children. Recently the speculation is that there was a drowning during the Gregg era, perhaps of a grandchild since both of Gregg's children were adults when Rock Hill was purchased. Since there is very little known about the Gregg occupancy, this is still a mystery. This sign, however, that says "Nurses And Children Not Allowed Around Lake" was in place when the Smyths acquired Connemara. (Courtesy of Julianne K. Heggoy collection, the Carl Sandburg Home, NHS.)

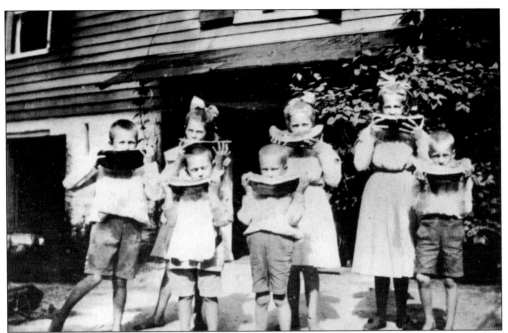

Outside the main house at Connemara, a group of Smyth grandchildren are seen eating watermelon. From left to right in the second row are granddaughter Mary Smyth, Nancy Blake, and Sissy Blake with four unidentified little boys. The captain built the lake below the barn shortly after 1900. Ice was taken from the lake and stored in the ice house with two layers of sawdust. It was a great place to cool watermelon. (Courtesy of William McKay collection, the Carl Sandburg Home, NHS.)

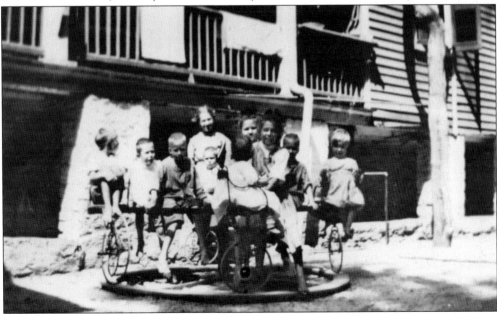

Captain Smyth built a turnstile play area for his grandchildren and their friends, seen here. The older children, using bicycles, would peddle the little ones. Note the little boys wearing dresses and no shoes. All the little boys were allowed to go barefoot from May 1 until the end of summer. (Courtesy of William McKay collection, the Carl Sandburg Home, NHS.)

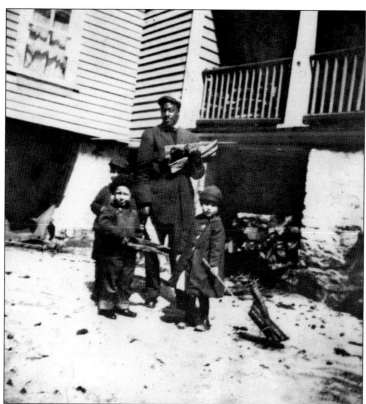

Taken in back of Connemara prior to the 1924 remodeling, this photograph shows a Smyth servant with three small, unidentified children. The servant is thought to be the Captain's chauffeur. The three children are helping him carry wood into the house for the fireplaces. (Courtesy of William McKay collection, the Carl Sandburg Home, NHS.)

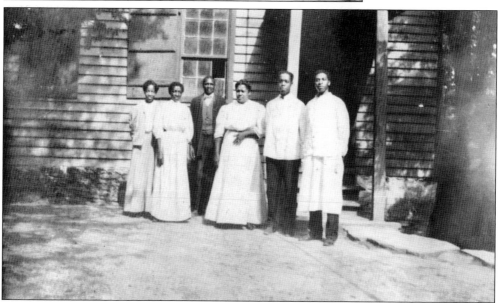

Captain Smyth's servants were loyal and were treated well. Here we see unidentified servants standing in front of the cookhouse. The Captain was a very prompt man and demanded his meals on time. The Captain's butler, chauffeur, and valet was James Fisher. The children called him "Lord Fisher" behind his back because he ran the house and always was available for the captain. (Courtesy of William McKay collection, the Carl Sandburg Home, NHS.)

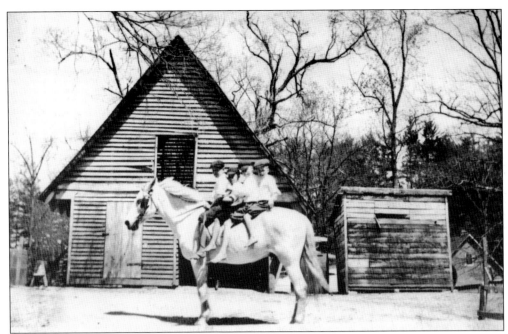

The Smyth grandchildren had the run of Connemara during their summer visits. The boys had lakes to swim in; donkeys, sheep, and cows to play with; and Glassy Mountain to climb. The girls played games. In the spring when the sheep were sheared, both the collie dogs and the boys got severe haircuts. Here we see four unidentified youngsters riding bareback on the grounds. (Courtesy of William McKay collection, the Carl Sandburg Home, NHS.)

Seen here by the barns are four Smyth grandchildren. Three unidentified little boys are playing with sheep, and on the right, Ellison (Joe) Smyth holds a baby calf. The grandchildren spent a month at Connemara each summer, alternating dates so all 21 grandchildren would be able to visit. (Courtesy of William McKay collection, the Carl Sandburg Home, NHS.)

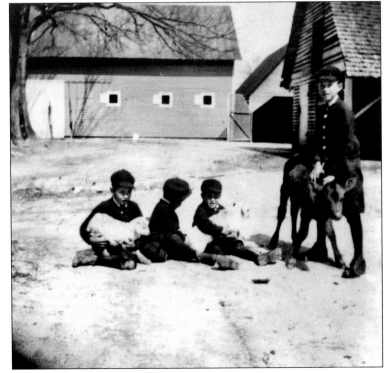

Although of poor quality, this photograph is the only image available of John and Sarah Smyth Hudgens, seen in the back seat. In the front seat, from left to right, are the Captain and Mr. Brissy. The Captain never drove a car. At one time, he owned a Pierce Arrow and then a La Salle, which were kept in the barn at Connemara. (Courtesy of Julianne K. Heggoy.)

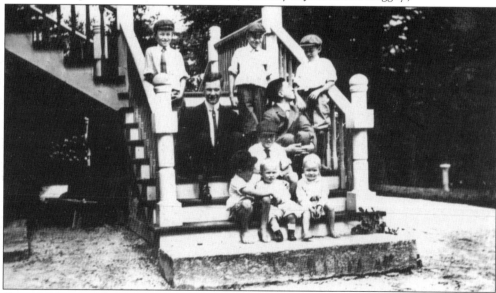

Connemara was to be a magical place for the Smyth grandchildren, and for the summer months when everyone visited, it was that. On the front steps, we see a gathering of grandchildren. Pictured here from left to right are (first row) Pierce Smyth, Moultrie Smyth, and Lewis Blake (Bootsie); (second row) unidentified boy; (third row, seated) Ellison McKissick and Ellison Smyth Blake; (fourth row, standing) Joe Smyth and two unidentified Blake children. (Courtesy of William McKay collection, the Carl Sandburg Home, NHS.)

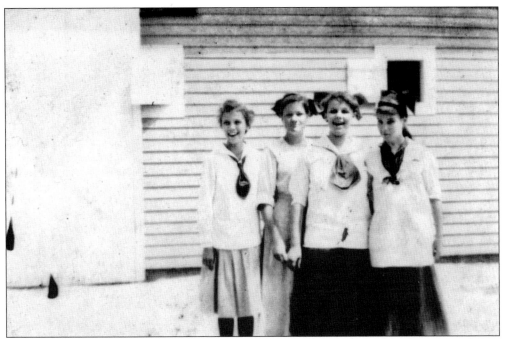

Dressed in their "middie" blouses, Smyth grandchildren pose in front of the barn. From left to right are an unidentified friend, Annie Pierce (Nancy), Julia Blake (Sissy), and Margaret Smyth McKay. The girls played games such as hopscotch, dolls, and jax. (Courtesy of William McKay collection, the Carl Sandburg Home, NHS.)

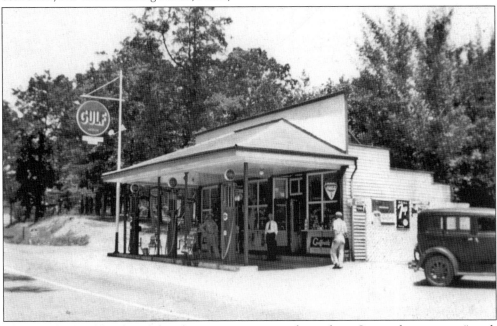

The Smyth granddaughters played games to entertain themselves. One such game was "mock church service," where the girls took collection of 5¢ per adult. Then they would walk to Peace's store on the Greenville Highway, seen here in a 1930s photograph, and buy Hershey bars. Little River Road was not paved at this time. (Courtesy of Barbara Peace Lohman.)

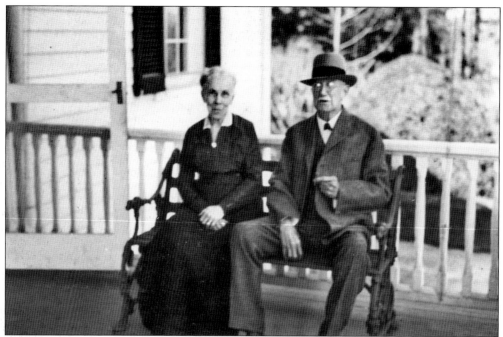

An already-successful Captain Smyth married Julia Gambrill when he was 22 years old. He was in Baltimore on business and saw her on a streetcar. He followed her home and asked her father if he could court her. They married in one year. Julia became a Presbyterian when they married. Eight of their 12 children are buried at the Second Presbyterian Church in Charleston. Seen on the front porch of Connemara are the Captain and Mrs. Smyth. She died in 1927. (Courtesy of Julianne K. Heggoy collection, the Carl Sandburg Home, NHS.)

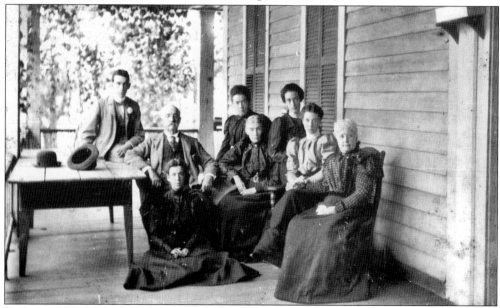

Thought to have been taken on the porch of Connemara in the autumn of 1906 when the family was about to leave for the season, this photograph shows a Smyth family gathering including, on the far right, family friend Mrs. Briggs. (Courtesy of Julianne K. Heggoy.)

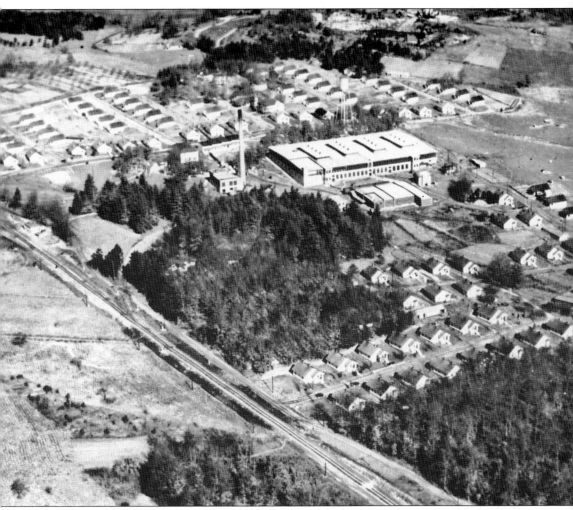

Seen in this photograph are Balfour Mills and the mill village, built by Captain Smyth around 1925. He bought property for the mill from the Presbyterian Children's Home. The Captain was a great man to work for, so many of his employees from the Pelzer mills followed him to Henderson County to work at the new mill. The Captain built the mill for his only son, James Adger, to operate. The mill village was laid out with rows of four-room houses and six-room houses, with streets of cinder. Smyth Avenue was the main street, where all houses were six rooms. When a worker was promoted, he and his family moved up to one of these six-room houses. When a young lady from the village was married, the Captain gave her a set of sterling silver teaspoons with her initials engraved on them. The Captain's son, James Adger Smyth, died in 1928. (Courtesy of Grace Gaillard.)

Seen in this photograph, taken at the east side of the front entrance to Connemara, is a group of unidentified young Smyth grandchildren. This photograph was taken around 1902 when the house was painted green. In the background, one can see a nursemaid keeping an eye on the children. (Courtesy of Julianne K. Heggoy collection, the Carl Sandburg Home, NHS.)

Seen in this photograph taken on the front lawn of Connemara are unidentified Smyth grandchildren. In the background is a Franklin car parked in the turnaround. Although a staunch Presbyterian, the Captain often walked to St. John in the Wilderness Episcopal Church with his family. (Courtesy of William McKay collection, the Carl Sandburg Home, NHS.)

Pictured on the front lawn at Connemara is Captain Smyth (second from right) with an unidentified group of sons-in-law and a baby grandchild in his lap. They are relaxing near the sundial that now stands at Windy Hill, home of the Captain's great-great-granddaughter Julianne K. Heggoy. In the background, lush boxwoods, remnants of the Memminger era, can be seen. (Courtesy of William McKay collection, the Carl Sandburg Home, NHS.)

Standing near the front entrance to Windy Hill is the sundial from Connemara, also seen in the photograph above. It stands as a reminder of the Smyth family home and the wonderful years spent together as a family.

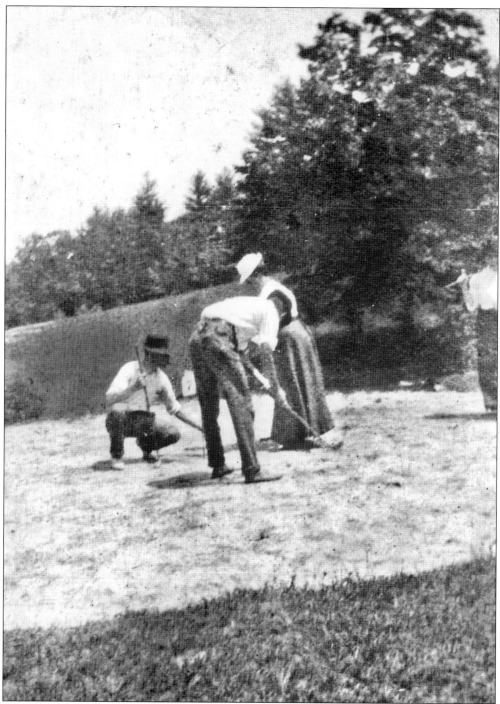

The Smyths' daughter, Annie Pierce, is seen in this old photograph playing golf on the Connemara Golf Links, hole number seven. Her husband, Lewis Blake, is on the left. An unidentified gentleman golfer is about to putt on the green made of hard sand and clay, while an unidentified woman waits at the edge of the green. (Courtesy of Julianne K. Heggoy collection, the Carl Sandburg Home, NHS.)

Soon after the Captain and Mrs. Smyth acquired Connemara, the Captain built a golf course. There were nine holes, eight of which were used once; one hole was used twice. The tee boxes were six by six feet and were filled with sand. The first drive was from a tee box below the barn, across the little lake. The holes took golfers around the pasture and along Little River Road. When they arrived at hole number eight, they drove across the lake again for the ninth hole. Bill McKay, the Captain's youngest great-grandson, remembers being able to still see the outlines of the golf course for many years after the Captain's death. The golf course was the first in Henderson County. In these two photographs, the Local Rules in the year 1906 and the score card for the Connemara Golf Links can be seen. (Courtesy of William McKay.)

LOCAL RULES, 1906.

A ball driven out of bounds may be dropped on the fair green with the loss of one stroke.

A ball falling in a rut cow track, ditch or marsh may be lifted and dropped over the shoulder with the loss of one stroke.

A ball falling near a tree or fence may be moved two club lengths without penalty, but not nearer to the green

Connemara Golf Links

FLAT ROCK, N. C.

Date —

Self —

Opponent —

No		Self	Opponent	Bogey	Self	Opponent
1	The Road 158			4		
2	The Pine 163			4		
3	The Woods 181			4		
4	The Branch 230			5		
5	The Return 287			5		
6	The Hedge 164			4		
7	The Cliff 120			4		
8	The Marsh 258			5		
9	Homeward 124			4		
	Totals--16 85			39		

Totals 9 Holes -

Handicap - -

Net - -

Charming Windy Hill has been a Smyth family property since 1921. It was home to the paternal grandparents of Thomas Hudgens and his sister, Julianne K. Heggoy, both great-great-grandchildren of Captain and Mrs. Smyth. Windy Hill is available for weekend and week-long visits.

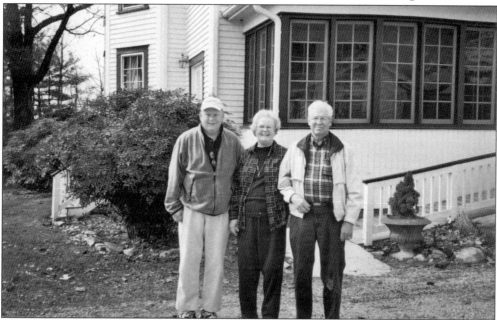

Seen in this recent photograph while standing outside Windy Hill are, from left to right, Thomas Hudgens, Julianne K. Heggoy, and their cousin, William McKay. McKay, the youngest of the Smyth great-grandchildren, remembers well visiting the Captain at Connemara every Sunday afternoon. His mother, Mary H. Smyth McKay, was born in the west front room at Connemara and told him about growing up there.

Three

THE SANDBURG ERA

Carl August Sandburg was born in Galesburg, Illinois, to Swedish immigrant parents in 1878. Sandburg left grade school in the eighth grade, and in 1897, he went to work doing a wide variety of jobs. He even rode the rails as a hobo, where he became interested in singing and collecting folk songs. During the Spanish-American War, he served with the 6th Infantry Regiment of the Illinois Volunteers. As a veteran, he attended Lombard College in Galesburg, Illinois. Sandburg campaigned for social democracy, writing and making speeches. It was at party headquarters that he met his wife to be, Lilian Steichen, sister of Edward Steichen, already a well-recognized photographer. Carl Sandburg was a prolific writer who would become a poet, biographer, reporter, novelist, editor, and lecturer, always in demand. In 1927, after receiving considerable recognition, the Sandburgs bought land in Harbert, Michigan, where Lilian Sandburg designed their large, comfortable house. It was here Sandburg wrote *Abraham Lincoln: The Prairie Years* and where Lilian Sandburg began her goat herd. In 1940, Carl Sandburg won the Pulitzer Prize for history for his four-volume *Abraham Lincoln: The War Years*.

The Sandburgs moved to Connemara in 1945. By this time, Lilian Sandburg was very involved with her Chikaming goat herd. It was she and her daughter, Helga, who picked Connemara as an ideal location not only for the peace and quiet necessary for Carl Sandburg's work, but for the goat herd. There was rolling pasture, tall pine trees for shelter, and a temperate climate. When Carl Sandburg came to see Connemara, he said "This is the place. We will look no further." When the Sandburgs moved to Flat Rock, they not only brought their entire dairy herd and all their belongings but also 21 tons of books. In 1956, Sandburg sold 6,000 volumes from his library to the University of Illinois for $30,000.

While living at Connemara, Sandburg published over one-third of his works, including *Complete Poems*, which won him his second Pulitzer Prize. It is fortunate for us all that Carl Sandburg's widow decided to offer Connemara to the federal government as a memorial to her husband. On October 17, 1968, Pres. Lyndon B. Johnson approved the congressional act, making the Carl Sandburg Home a National Historic Site, and it was included in the National Park System. The following summer, Mrs. Lilian Sandburg and her daughters Margaret and Janet moved to a new residence in Asheville.

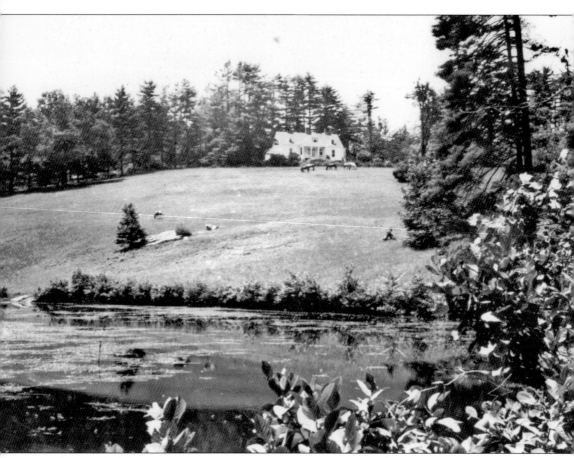

In this wonderful photograph of Connemara, the lake, the sloping pasture, and the house at the top of the hill, built on the side of Glassy Mountain, are all visible. The lake has always been an attraction to residents and visitors alike. There is now a walking trail around the lake for visitors' further enjoyment. (Courtesy of the Carl Sandburg Home, NHS.)

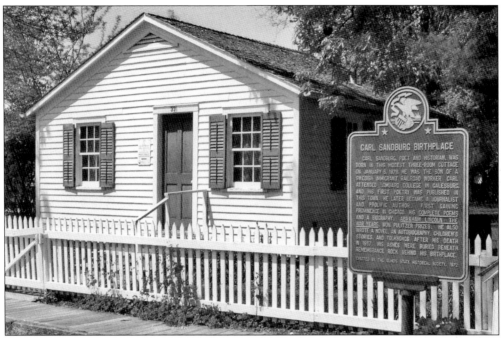

The postcard above shows the Carl Sandburg birthplace in Galesburg, Illinois. He was born in the three-room cottage January 6, 1878. The house is maintained by the Illinois Historic Preservation Agency, and many of the furnishings once belonged to the Sandburg family. Behind the modest house is a small park, where both Carl and Lilian Sandburg's ashes lie beneath Remembrance Rock. Pictured on the postcard below is the same cottage but painted brown. It was painted this color around 1946 to hide the soot smudges from the nearby railroad. It is now back to a light color, but some locals say it was always brown in the Sandburgs' time. (Courtesy of Steve Holden and the Historic Preservation Agency.)

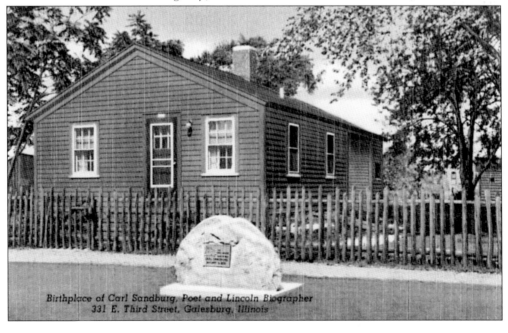

Birthplace of Carl Sandburg, Poet and Lincoln Biographer
331 E. Third Street, Galesburg, Illinois

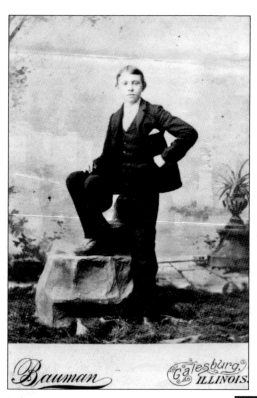

Carl Sandburg is seen here on the occasion of his graduation from grammar school in 1891. (Courtesy of the Carl Sandburg Home, NHS.)

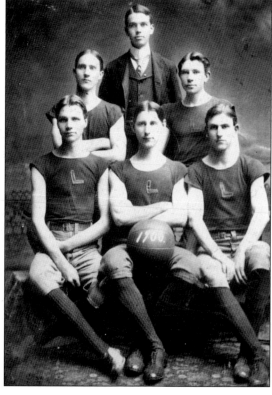

Carl Sandburg attended Lombard College in Galesburg, Illinois, where friends called him Cully. Although he left in his senior year before graduation, he had begun writing on a regular basis while a student. In 1901, he was the editor of the *Lombard Review* and the Lombard reporter for the *Galesburg Evening Mail*. This photograph shows him in the second row, far right with unidentified teammates on the basketball team. (Courtesy of the Carl Sandburg Home, NHS.)

The Sandburgs lived in this tall, many-windowed house on the Michigan dunes in Harbert, Michigan. Lilian Sandburg designed the comfortable house, but the winter weather and scarcity of pasture land for their goat herd caused them to search for a better climate and land, both of which they found at Connemara. (Courtesy of Paula Steichen Polega, the Carl Sandburg Home, NHS.)

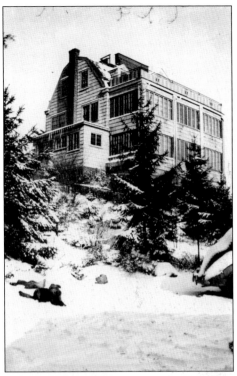

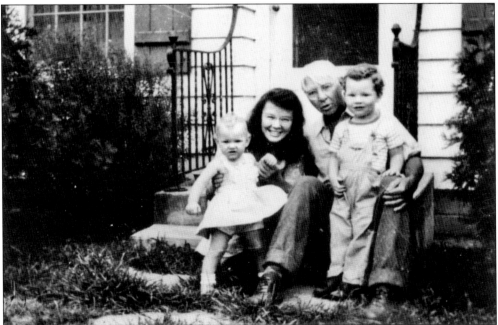

The Sandburgs began their Tom Thumb farm while living in Harbert, Michigan. Here we see three generations of Sandburgs posing on the steps of daughter Helga's orchard cottage, located on the Sandburg property in Harbert. From left to right are Paula, born in 1943; her mother, Helga; Carl Sandburg; and Helga's son, John Carl, born in 1941. (Courtesy of Paula Steichen Polega, the Carl Sandburg Home, NHS.)

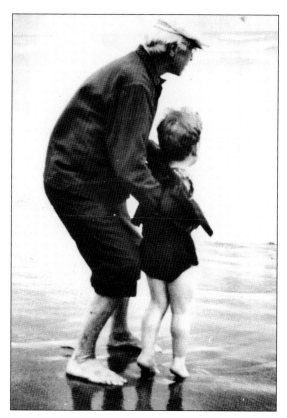

Every grandfather can relate to this picture. It shows Carl Sandburg with his very young grandson, John Carl, on the beach of Lake Michigan. Sandburg's grandchildren called him Buppong. (Courtesy of Paula Steichen Polega, the Carl Sandburg Home, NHS.)

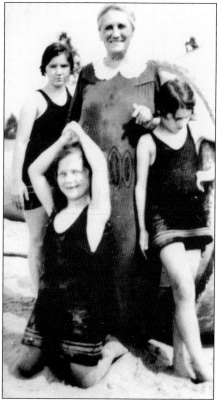

Dressed in their bathing suits on a visit to the beach at Tower Hill, Michigan, in the 1920s are the Sandburg sisters with their maternal grandmother, Mary Kemp Steichen, whom they called Oma, in the old country fashion. Steichen emigrated to the United States in 1880 from Luxembourg. This photograph shows, from left to right, Margaret, Helga kneeling in front, Steichen in the rear, and Janet. (Courtesy of Paula Steichen Polega, the Carl Sandburg Home, NHS.)

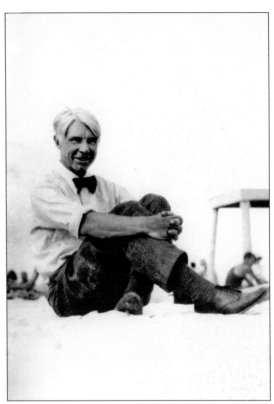

Seen at right and below are two photographs of Carl Sandburg relaxing at the beach. (Courtesy of Paula Steichen Polega, the Carl Sandburg Home, NHS.)

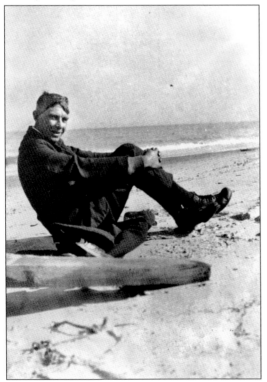

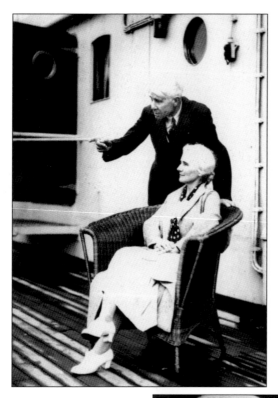

Pictured here in 1934 on an unidentified ocean liner are Carl and Lilian Sandburg on their way to Hawaii, where Sandburg had a speaking engagement at the University of Hawaii. Carl Sandburg traveled extensively, usually alone, but on this occasion, his wife, whom be affectionately called Paula, accompanied him. They made the trip a vacation for the two of them. (Courtesy of Paula Steichen Polega, the Carl Sandburg Home, NHS.)

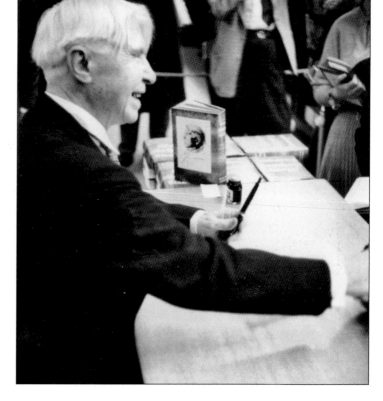

Carl Sandburg wrote one-third of his published works while living at Connemara. Here, in 1953, we see him at a book-signing event for his autobiography *Always the Young Stranger.* (Courtesy of the Carl Sandburg Home, NHS.)

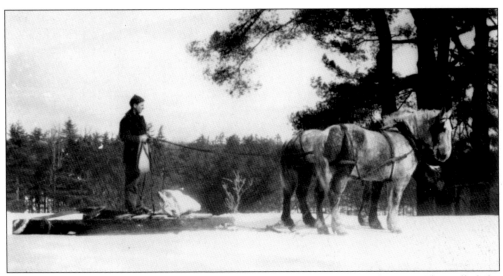

The workhorses at Connemara were giant Percherons named Pearl and Major. They tilled the fields in spring, pulled a spreader in the fall, and cleared the roads in winter after a snowstorm. These photographs show the herdsman, Grady Pace, working with the horses. (Courtesy of Paula Steichen Polega, the Carl Sandburg Home, NHS.)

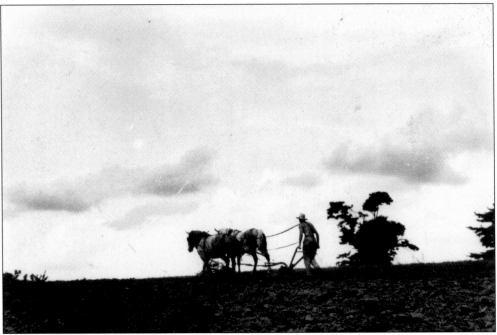

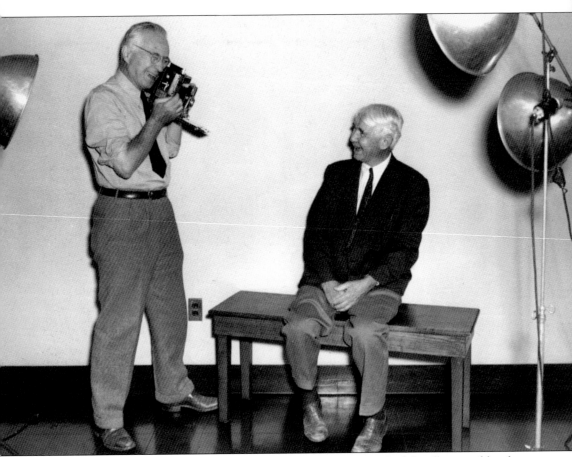

From the day they met at Lilian Steichen's family home in 1908, Carl Sandburg and his future brother-in-law, Edward Steichen, were friends. Their friendship would only grow through the years. Sandburg wrote *Steichen the Photographer*, a biography, and Steichen photographed Sandburg numerous times during his life. This photograph was taken September 4, 1946, when Sandburg took his famous brother-in-law photographer to meet his friend and photographer June Glenn Jr. at Glenn's studio at the *Asheville Citizen-Times*. (Courtesy of June Glenn Jr., the Carl Sandburg Home, NHS.)

Sandburg's Connemara was a place for children to enjoy. Pictured here from left to right are Betty Mintz, daughter of herdsman Frank Mintz; Sandburg's granddaughter, Paula; and her brother, John Carl. They are seen with the garage in the background, making their own fun. The garage was the original kitchen house and was converted to a garage by the Sandburgs in 1945. (Courtesy of Paula Steichen Polega, the Carl Sandburg Home, NHS.)

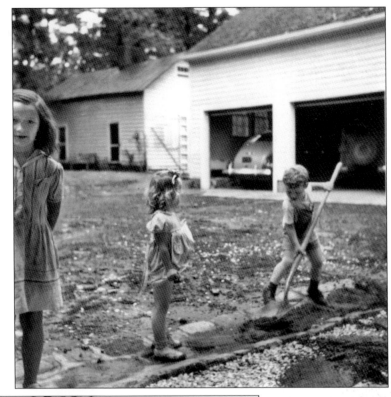

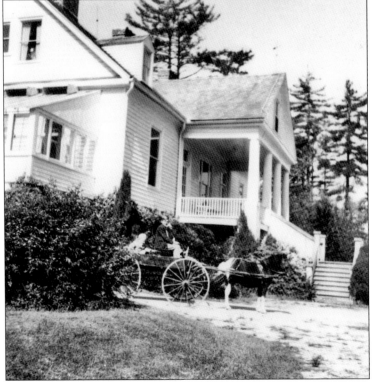

Taken in 1946 in front of the main house at Connemara, this photograph shows Sandburg's grandchild Paula and an unidentified boy in a cart being pulled by Patches, the pony. (Courtesy of Paula Steichen Polega, the Carl Sandburg Home, NHS.)

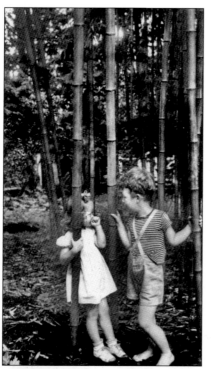

Connemara had and still has an abundance of areas in which to play, walk, and enjoy nature. Here we see Sandburg grandchildren, Paula and her brother, John Carl, playing in the bamboo forest. The children were encouraged to explore on their own and to develop a sense of independence. (Courtesy of Paula Steichen Polega, the Carl Sandburg Home, NHS.)

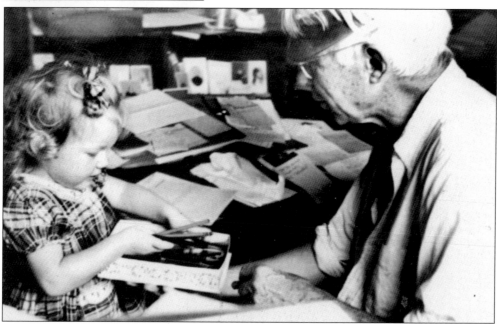

Seen in this charming photograph is Paula visiting her grandfather Carl Sandburg in his office. He was very patient with the children, and throughout the years, he wrote poems to Paula, whom he called Snick. The grandchildren called their grandfather Buppong. Sandburg wrote *The Rootabaga Stories*, charming works called "the fairy tales of America," when his own children were young. They are still enjoyed by children and adults alike. (Courtesy of Paula Steichen Polega, the Carl Sandburg Home, NHS.)

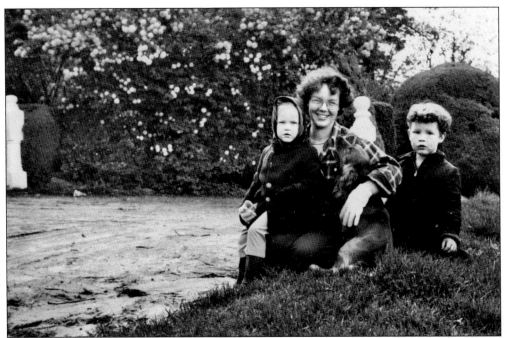

With the giant snowball bush in the background, Sandburg's daughter, Helga, sits with her two children, Paula on the left and John Carl on the right. They are sitting on the grass on the side of the driveway to the main house at Connemara. In the background are the newel posts taken from the front steps during the Smyth era. (Courtesy of Paula Steichen Polega, the Carl Sandburg Home, NHS.)

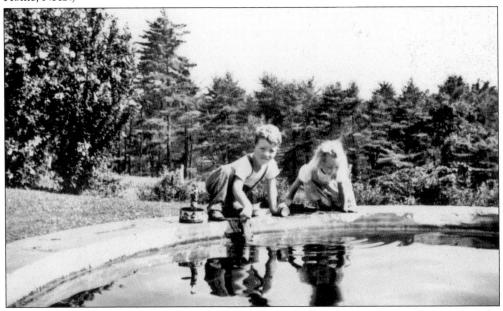

The little pool, seen here, was part of a large fountain built by C. G. Memminger c. 1840. The fountain had been dismantled, affording a great little play pool for the children. Here we see John Carl and Paula at play. The pool was great for sailing little boats and wading. (Courtesy of Paula Steichen Polega, the Carl Sandburg Home, NHS.)

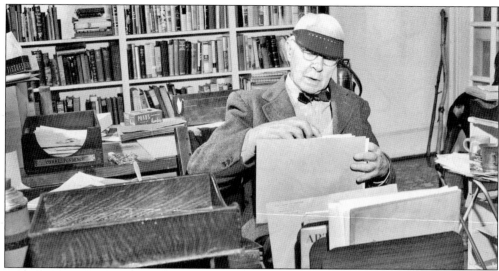

Working in his office at Connemara provided Carl Sandburg with the luxury of not only having all his reference materials at hand, but also his family. A short walk to the dining room brought everyone together for delicious, homemade meals to his liking. He had an incredible work ethic, and after his grandchildren left Connemara, he found time to write to them daily. This photograph was taken in 1956. (Courtesy of June Glenn Jr., the Carl Sandburg Home, NHS.)

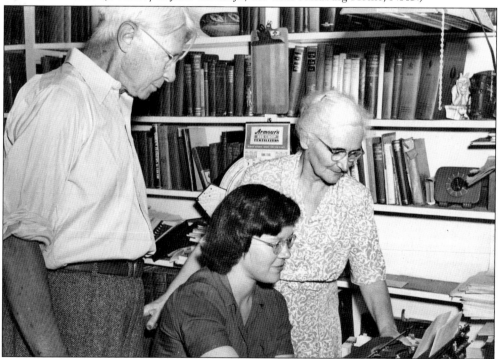

Helga, the Sandburgs' youngest daughter, took an active part in the goat operations and also helped her father with dictation for letters and typing manuscripts. Sandburg had help typing his great volume of work from several ladies, one of whom was a young Louise Bailey, noted local author and historian. Here we see in 1946, from left to right, Carl Sandburg, Helga at the typewriter, and Mrs. Sandburg. (Courtesy of June Glenn Jr., the Carl Sandburg Home, NHS.)

Taken in 1951 by the side of the main house at Connemara, this photograph shows Carl Sandburg holding the reins while his granddaughter, Paula, prepares to go for a ride on her horse, Remember. The horses were kept mostly for riding, but two work horses, the Percherons, were also kept for a time on the farm. Some names of the riding horses were Grey Boy, Blueberry, Kentucky, Paper Doll, and Storm. (Courtesy of Paula Steichen Polega, the Carl Sandburg Home, NHS.)

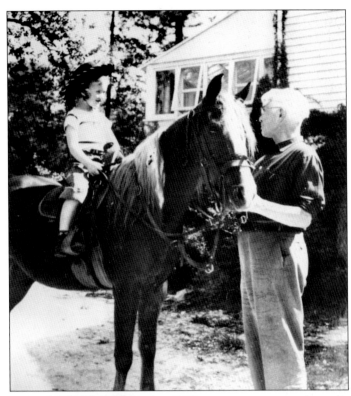

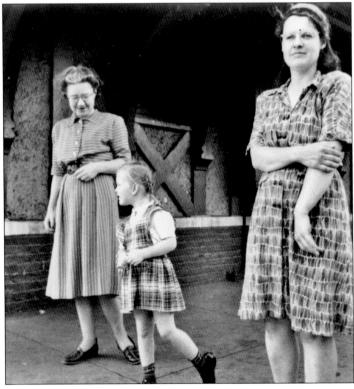

It was always a happy occasion when Mrs. Sandburg's brother, Edward Steichen, paid a visit. Here is a photograph of (from left to right) Carl Sandburg's daughter Margaret; granddaughter, Paula; and daughter Janet waiting on the platform of the Biltmore train station for their Uncle Ed's train. (Courtesy of Paula Steichen Polega, the Carl Sandburg Home, NHS.)

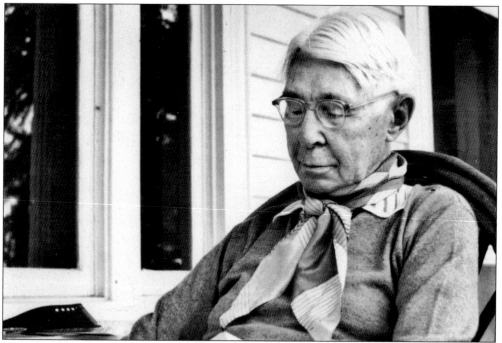

When the weather was mild, Carl Sandburg would take his mail and reading materials outdoors, often to the front porch. Here he is pictured sitting in a favorite chair on the front porch. He loved the outdoors. He said, "It is necessary now and then for a man to go away by himself and experience loneliness, to sit on a rock in the forest." He often took long walks, sometimes at night. (Courtesy of June Glenn Jr., the Carl Sandburg Home, NHS.)

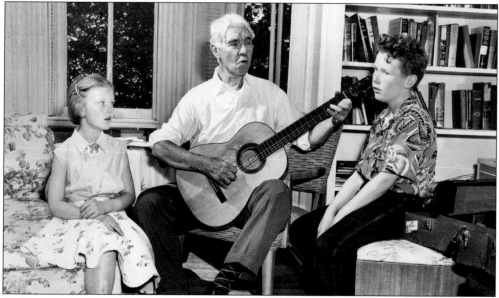

Carl Sandburg is seen here playing guitar and singing in Lilian Sandburg's bedroom at Connemara. On the left is his granddaughter, Paula, and on the right his grandson, John Carl. Sandburg started collecting folk songs during his days as a hobo, and his fascination with them never ceased. (Courtesy of June Glenn Jr., the Carl Sandburg Home, NHS.)

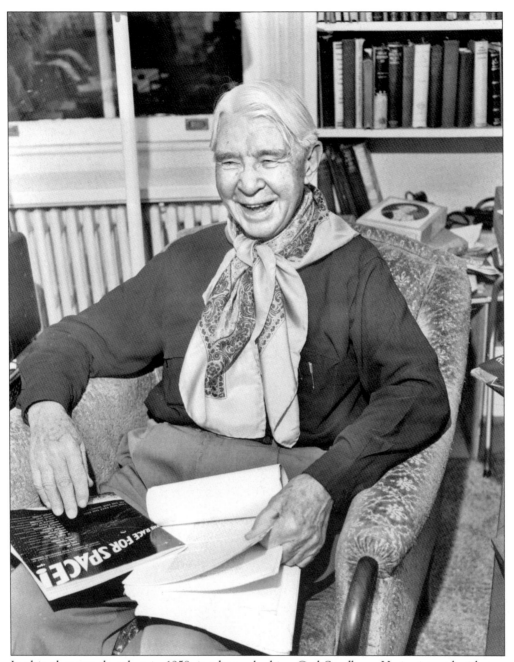

In this photograph, taken in 1958, is a happy-looking Carl Sandburg. He is pictured with one of his many scarves around his neck looking over a manuscript and about to read *The Race for Space*. He was intrigued with transportation and technology. (Courtesy of June Glenn Jr., the Carl Sandburg Home, NHS.)

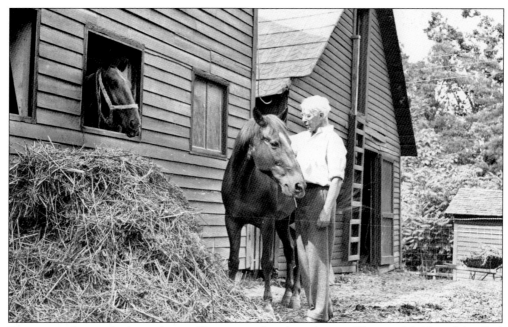

There were always a few horses kept at Connemara for riding pleasure. The grandchildren, John Carl and Paula, learned to ride and trust horses at a very early age. Here we see Carl Sandburg paying a visit to Remember at the barn. Remember was a beautiful chestnut gelding show horse that was brought to Connemara when he was about 15 years old. He was first Helga's horse and then she gave him to her daughter, Paula. (Courtesy of June Glenn Jr., the Carl Sandburg Home, NHS.)

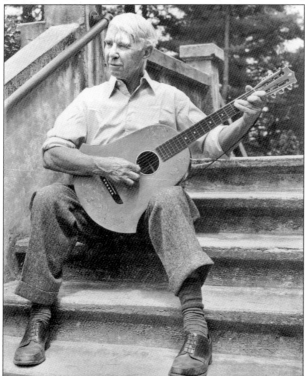

Carl Sandburg enjoyed playing his guitar and singing folk songs. He sang and played guitar after family dinners and would gladly oblige when asked to perform. When he was working, classical music would be heard on the phonograph. In this photograph, he's playing guitar and singing on the steps of Connemara. He ended his lectures with folk songs and published *The American Songbag*. (Courtesy of June Glenn Jr., the Carl Sandburg Home, NHS.)

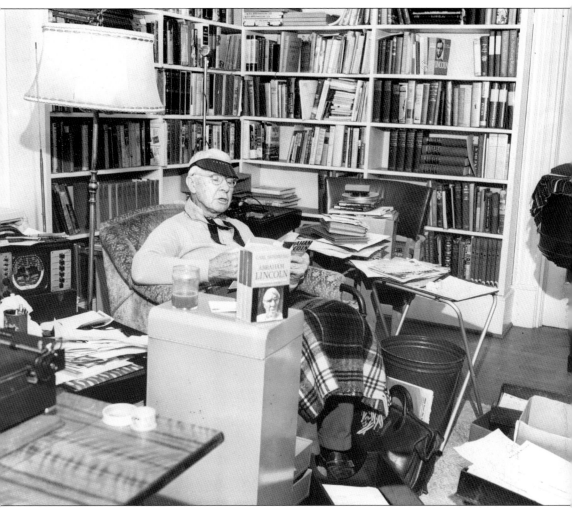

On February 12, 1959, the 150th anniversary of Abraham Lincoln's birthday, Sandburg addressed a joint session of Congress. Here he is pictured on January 5, 1959, in a corner of the front room at Connemara, preparing for his speech. He is shown in an easy chair, lap robe over his knees, surrounded with reference material. (Courtesy of June Glenn Jr., the Carl Sandburg Home, NHS.)

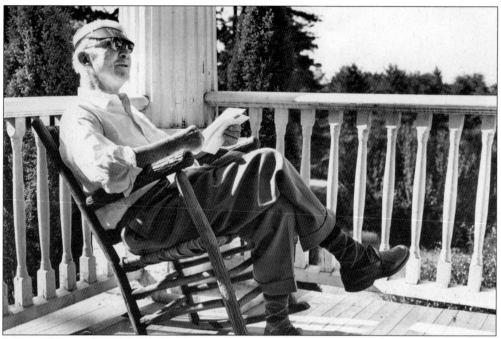

Pictured here is a great view of Carl Sandburg in a favorite rocking chair on the front porch of Connemara. Sleeves rolled up and favorite newspaperman's visor on, he appears to be enjoying the afternoon's mail. (Courtesy of June Glenn Jr., the Carl Sandburg Home, NHS.)

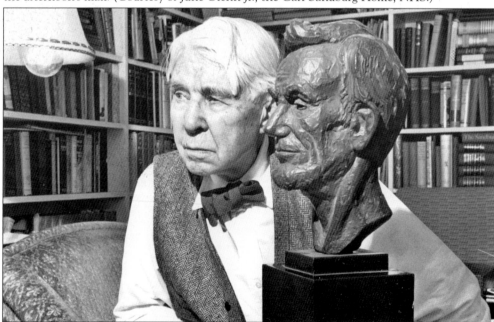

Almost annually near Sandburg's birthday, June Glenn Jr. visited Connemara. In the process, they became good friends. Here, in 1960, Glenn photographed Sandburg posing beside a bust of Lincoln. Sandburg wrote *Abraham Lincoln: The Prairie Years* in 1926, which was his first financial success. He spent the next several years writing *Abraham Lincoln: The War Years*, which won him the 1940 Pulitzer Prize. (Courtesy of June Glenn Jr., the Carl Sandburg Home, NHS.)

In 1963, Carl Sandburg was presented with an award of appreciation from local businesses. It read: "All Western North Carolina Salutes Its Own Carl Sandburg." Seen in this photograph at the presentation are, from left to right, Sadie Patton, local author, historian, researcher and philanthropist; Congressman Jamie Taylor; Carl Sandburg; and Mrs. Sandburg. (Courtesy of June Glenn Jr., the Carl Sandburg Home, NHS.)

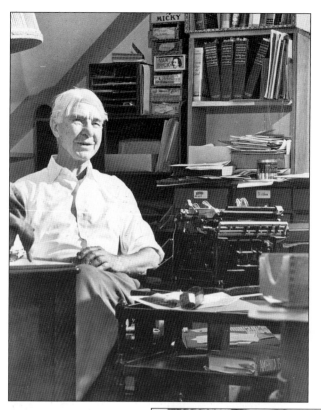

This photograph shows Sandburg in his office surrounded by books, magazines, and reference materials. He was a prolific writer and worked almost constantly on books, poems, and articles. (Courtesy of June Glenn Jr., the Carl Sandburg Home, NHS.)

Carl Sandburg, using his boundless imagination, created a fictitious personality, Mr. McGuillicudy. In the spring, Sandburg set a three-legged branch on the front porch. He put his floppiest hat on top and called it his new acquaintance. After the branch was carried off by a dog, he threw a sweater over the back of a chair, put a hat on top and boots at the foot. Sandburg declared, "Mr. McGuillicudy is enjoying the view now." (Courtesy of Paula Steichen Polega, the Carl Sandburg Home, NHS.)

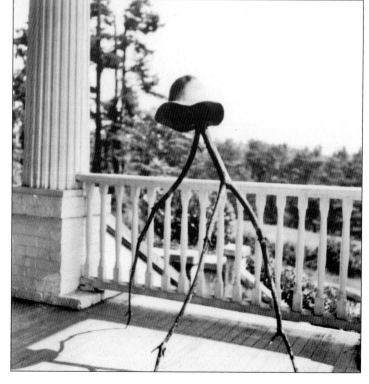

Here we see a photograph of Carl Sandburg's chair on the rock. He spent many days working out of doors. His chair and little table were set on the granite rock outcropping at the edge of the woods behind the house. He worked there all afternoon sometimes in the blazing sun, wearing his green newspaperman's visor. (Courtesy of Paula Steichen Polega, the Carl Sandburg Home, NHS.)

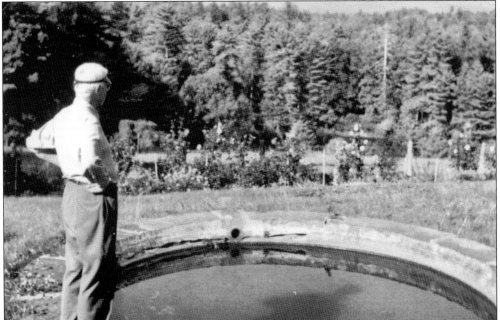

In this photograph, Sandburg is shown standing beside the little pool that had been part of a fountain in earlier years. He is looking out over the front lawn toward the lake and beyond. Running from left to right is Mrs. Sandburg's garden of dahlias and zinnias growing along the fence line. Past the garden, one can see a faint outline of the Blue Ridge Mountains. (Courtesy of Paula Steichen Polega, the Carl Sandburg Home, NHS.)

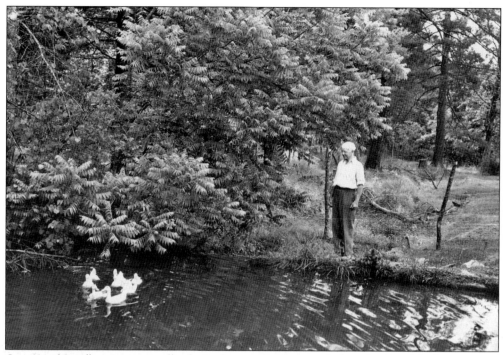

On one of Sandburg's many walks, he is shown stopping to admire a family of ducks on one of Connemara's lakes. (Courtesy of Paula Steichen Polega, the Carl Sandburg Home, NHS.)

Lilian Sandburg loved her gardens and tended them with great enjoyment. Here the camera seems to have surprised her at her garden of lilies, blue delphiniums, and pink petunias. Behind the lattice is the kid room, where baby goats were nurtured for the first two to three weeks of their lives before being moved to the chicken house, their next living quarters. (Courtesy of Paula Steichen Polega, the Carl Sandburg Home, NHS.)

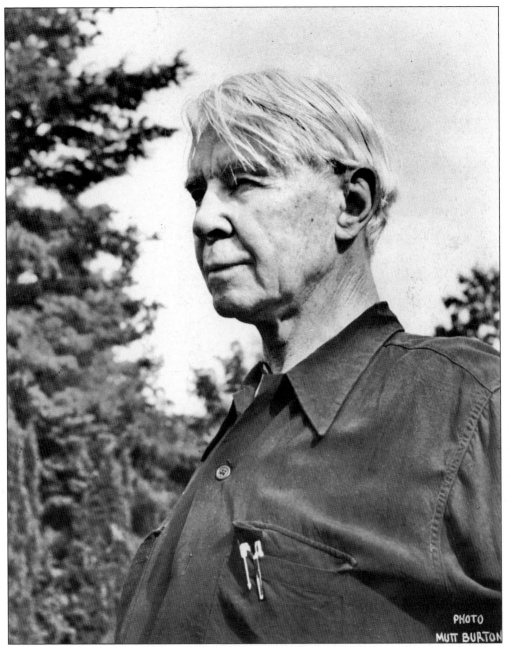

PHOTO
MUTT BURTON

In addition to being an excellent photographer, Mutt Burton was a journalist in Greenville, South Carolina. He became interested in the Flat Rock Playhouse, the State Theatre of North Carolina, located across Little River Road from Connemara. He was a well-loved visitor to the theater and performed in several plays in the 1950s. Burton and Carl Sandburg met at a playhouse function and became friends. This is a photograph taken by Burton in the 1950s of Carl Sandburg. (Courtesy of the Flat Rock Playhouse.)

Lilian Sandburg seems to be trying to get the dog Toni to look at the camera in this picture. Mrs. Sandburg and her dogs, Toni and Christina, are seen in the kitchen of Connemara. A close look reveals a country kitchen of a very busy family. (Courtesy of Paula Steichen Polega, the Carl Sandburg Home, NHS.)

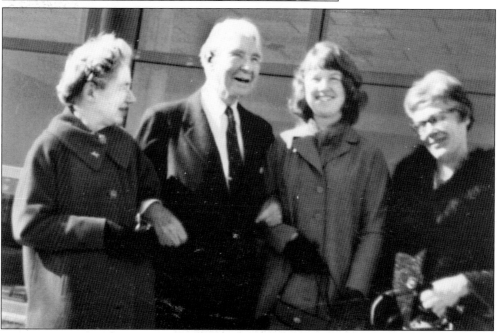

Travel was a part of life for Carl Sandburg. His family accepted this fact, but it was always an occasion to see him off or greet him on his return. This photograph, taken in 1960, shows him on one of these occasions. From left to right are Sandburg's daughter Margaret; Sandburg; his granddaughter, Paula; and Sandburg's daughter Helga. He was leaving on a trip to Hollywood. (Courtesy of Paula Steichen Polega, the Carl Sandburg Home, NHS.)

This is an early photograph of Janet Sandburg holding a kitten. Although her favorite animals were cats, she would become a tireless worker with the goat herd. She rose at 5:30 a.m. to give the baby goats their first feeding of the day. When they saw her coming, they would bleat with anticipation. (Courtesy of Paula Steichen Polega, the Carl Sandburg Home, NHS.)

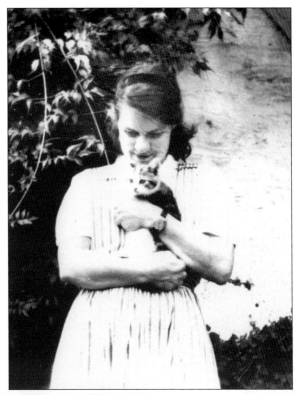

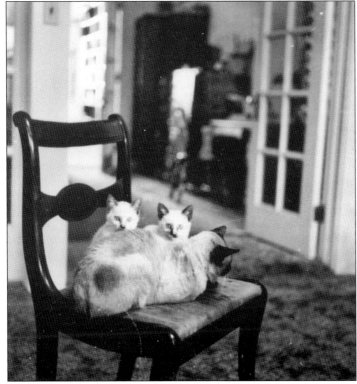

In addition to Helga's involvement with the goat herd, she also raised Doberman pinschers and Siamese cats. This photograph shows three happy cats in the main house at Connemara on top of a dining room chair. (Courtesy of Paula Steichen Polega, the Carl Sandburg Home, NHS.)

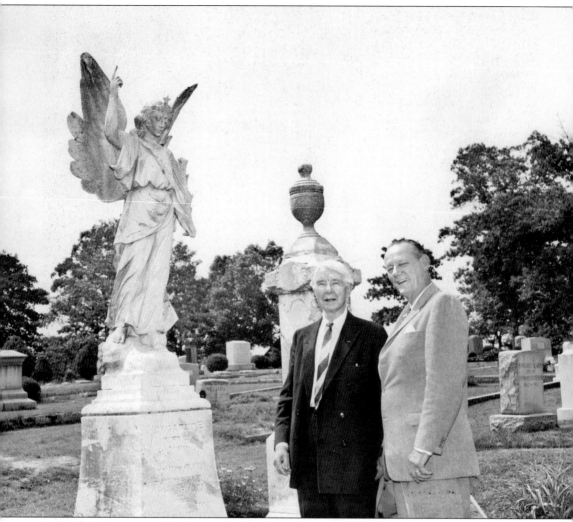

In Oakdale Cemetery in Hendersonville, North Carolina, stands Wolfe's Angel, the angel monument referenced in Asheville's hometown author Thomas Wolfe's novel *Look Homeward Angel*. The monument was crafted in Italy and purchased from Wolfe's father by the Johnson family for their family cemetery plot. The monument is now surrounded by an iron fence. In this photograph, we see Carl Sandburg on the left and Mayor Al Edwards on the right. Mayor Edwards was the undefeated mayor of Hendersonville for 37 years, the longest service as a mayor in U.S. history. (Courtesy of Marsha Mills-Kelso, the Carl Sandburg Home, NHS.)

Carl Sandburg's middle daughter, Janet, arose at dawn each morning to feed the baby goats. Several times a day, she would measure heated milk into pans for single, twin, and triplet kids, who would feed in a happy frenzy. Also every morning, she brought her father's breakfast tray to his door. On it was a piece of cheese, dark bread, a glass of goat milk, a thermos of coffee, a jar of honey, and fruit. (Courtesy of June Glenn Jr., the Carl Sandburg Home, NHS.)

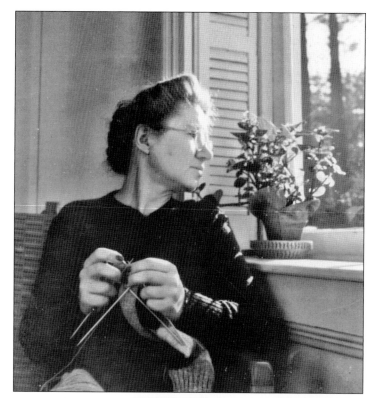

Margaret, whom her father called Marne, was the oldest of the Sandburg children. Her life revolved around Connemara's library of books and her own intellectual pursuits, rather than farm activities. Here she is shown knitting beside a sunny window. (Courtesy of Paula Steichen Polega, the Carl Sandburg Home, NHS.)

Sandburg's daughter Helga was not only involved with maintaining the goat herd, she also was an artist, as seen here. (Courtesy of Paula Steichen Polega, the Carl Sandburg Home, NHS.)

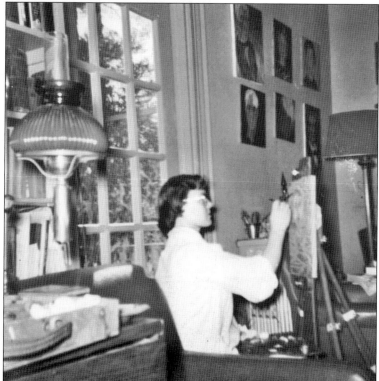

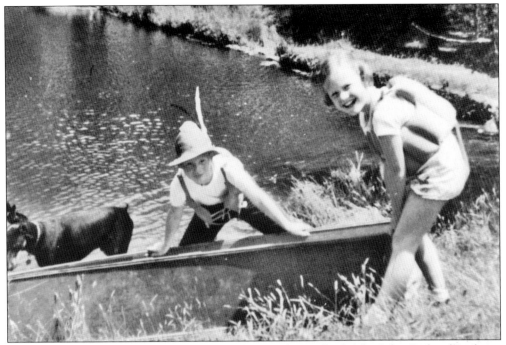

The grandchildren were allowed to swim and boat in the small side lake. John Carl and Paula are seen in this 1951 photograph preparing to go out in their rowboat. (Courtesy of Paula Steichen Polega, the Carl Sandburg Home, NHS.)

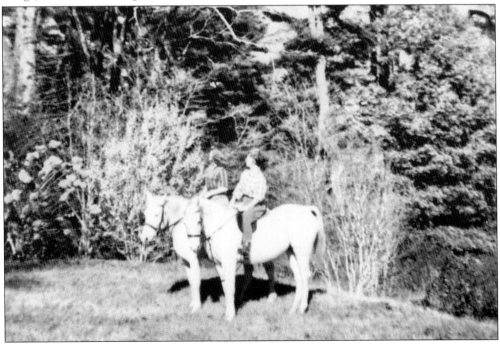

In this undated photograph, we see Sandburg's granddaughter, Paula, on the left and her mother, Helga, riding borrowed horses, Lady Gray and It's Up, while on an autumn visit to Connemara. (Courtesy of Paula Steichen Polega, the Carl Sandburg Home, NHS.)

Carl Sandburg

1878-1967

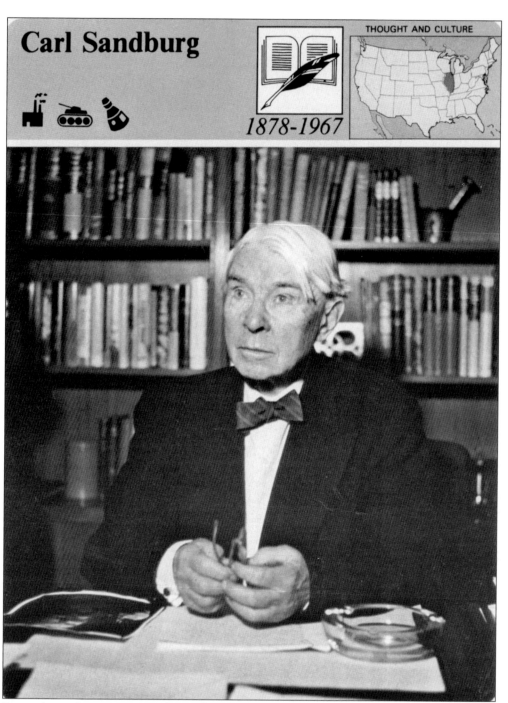

Biography cards were very popular in the 1960s and 1970s. Carl Sandburg's biography is on the reverse side of this card. The cards were educational and inexpensive. This card is titled "Poet of the People."

Seen above and below are two first-day issues commemorating the 100th birthday of Carl Sandburg, January 6, 1978. They are both post-marked Galesburg, Illinois, the town of his birth. The postage on the cards was 13¢.

When the Sandburgs purchased Connemara, there were more than 11 buildings on the property. This photograph is of towering boxwoods, undoubtedly planted by C. G. Memminger. Across the drive by the barn were elaborately terraced gardens that would become the Sandburgs' vegetable garden. Some of the boxwoods were given to Memminger's relatives. (Courtesy of Paula Steichen Polega, the Carl Sandburg Home, NHS.)

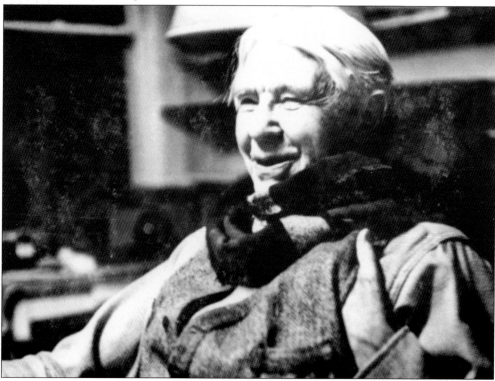

In this photograph, we see a happy-looking Carl Sandburg with one of his favorite scarves around his neck. When the Sandburgs bought Connemara, Sandburg is quoted as saying, "We didn't buy a farm. We bought a small village." (Courtesy of the Carl Sandburg Home, NHS.)

In 1948, author and poet Carl Sandburg returned to Galesburg, Illinois. This photograph was taken when he paid a visit to his birthplace, a three-room cottage at 331 East Third Street, now a Carl Sandburg State Historic Site. (Courtesy of the Carl Sandburg Home, NHS.)

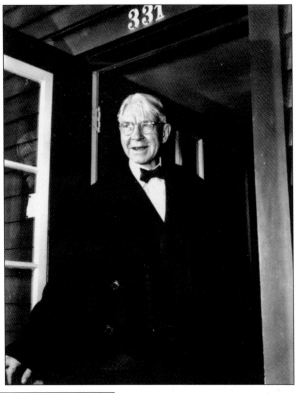

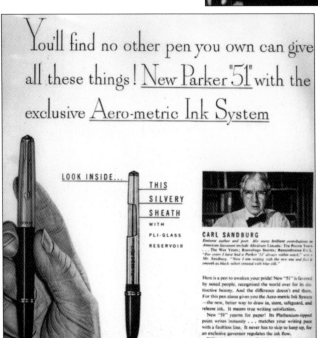

You'll find no other pen you own can give all these things! New Parker "51" with the exclusive Aero-metric Ink System

LOOK INSIDE...

THIS SILVERY SHEATH WITH PLI-GLASS RESERVOIR

CARL SANDBURG

At the height of Carl Sandburg's career, he was not only in great demand as a speaker, but he participated in many advertising campaigns. Here we see him advertising the New Parker 51 pen. His image was a popular choice for such magazines as *Life* and *Time*, among others.

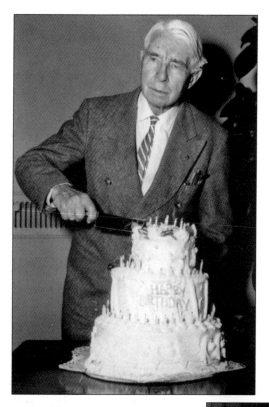

In 1963, Sandburg's publisher, Harcourt, Brace, and World, arranged a birthday celebration for him. Here he is shown about to cut a three-tiered cake. Also being celebrated was the publication of his book *Honey and Salt*. (Courtesy of the Carl Sandburg Home, NHS.)

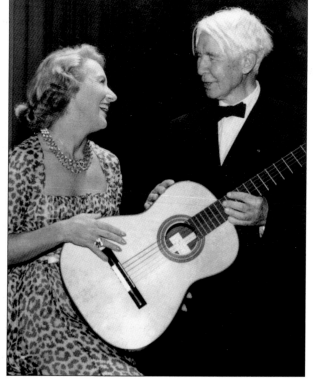

In this undated photograph, we see Carl Sandburg with actress Arlene Francis. Dressed in formal attire, it appears that he's about to play guitar and sing folk songs, something that quite regularly happened at the end of speaking engagements. (Courtesy of the Ewart McKinley Ball Jr. family and the Carl Sandburg Home, NHS.)

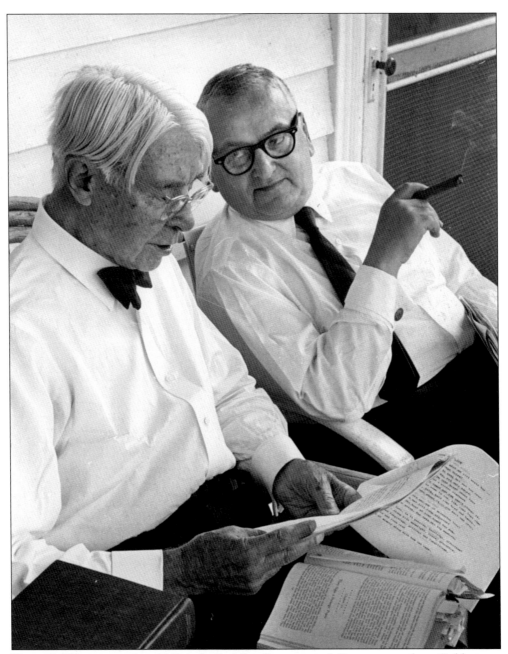

Harry Golden, pictured in 1962 with Carl Sandburg, visited Connemara often. Golden was born in 1902 in the Jewish ghetto of what is now Mikulintsy, Ukraine, then part of Austria-Hungary. He emigrated to the United States as a child and became a stockbroker only to lose his job in the 1929 crash. Convicted of mail fraud, he spent five years in prison. He later moved to Charlotte, North Carolina, where he became a successful writer, reporter, and publisher. An extremely interesting person, he and Carl Sandburg became good friends and kept up a regular correspondence, both prior to and after Golden wrote his biography *Carl Sandburg*. In 1974, Golden received a presidential pardon from Richard Nixon. He died in 1981. (Courtesy of June Glenn Jr., the Carl Sandburg Home, NHS.)

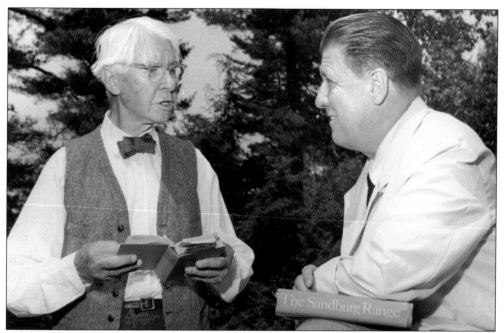

Carl Sandburg spent time in Hollywood on many occasions. He was script consultant for the movie *The Greatest Story Ever Told*. In June 1960, Hollywood producer George Stevens visited Connemara. Seen here, Sandburg and Stevens are discussing *The Sandburg Range*, an anthology of Sandburg's works published in 1957. (Courtesy of June Glenn Jr., the Carl Sandburg Home, NHS.)

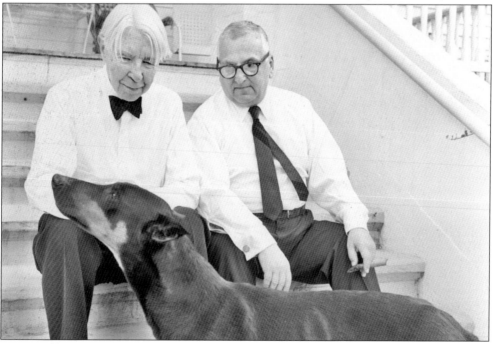

Harry Golden, seen here on the right, visits with Carl Sandburg on the front steps of Connemara in 1962. One of Helga's Doberman pinschers is pausing to check them out. (Courtesy of June Glenn Jr., the Carl Sandburg Home, NHS.)

Here we see Carl Sandburg on January 19, 1965, holding a photograph taken on April 20, 1964, when the Sandburgs and the Steichens visited Pres. Lyndon Johnson and toured the White House. In September 1964, Sandburg was presented the Presidential Medal of Freedom. (Courtesy of June Glenn Jr., the Carl Sandburg Home, NHS.)

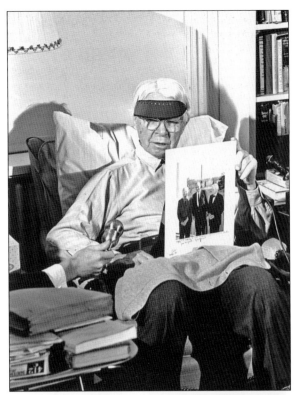

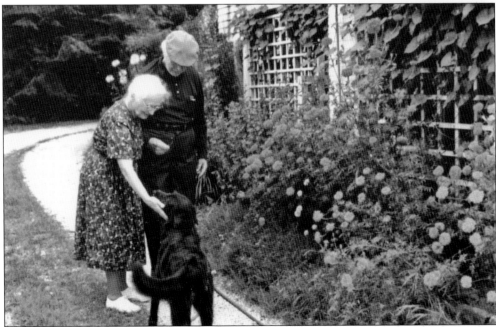

Toward the end of Sandburg's life, he and his beloved wife took many walks together in the gardens. Taken in 1966, this touching photograph shows them walking past the zinnia garden. Mrs. Sandburg is greeting their dog Toni. (Courtesy of Paula Steichen Polega, the Carl Sandburg Home, NHS.)

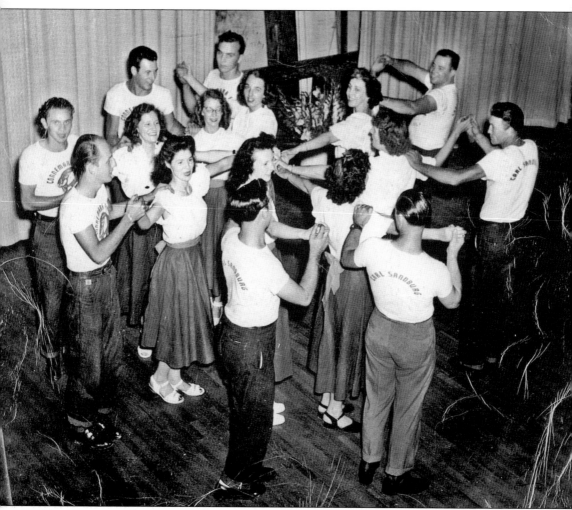

The Connemara Farms square dance team won the championship at the Rock Island Railroad Fair in 1948. Started by Sandburg's herdsman, Frank Mintz, the team would often practice in the Sandburgs' barn. Sometimes the Sandburg grandchildren would be allowed to watch them practice. Pictured here counterclockwise from top left are Jim Hinson and Peggy Jones, Cecil Hyder and Helen Drake, Charles Stepp and Geraldine Drake, Byron Reed and Hazel Arrowood, Marvin Orr and Marilyn McClain, Frank Mintz with his back to the camera and Dolly Mintz, Reynolds and Emma McGaha, and Bob Williams and his wife. (Courtesy of Geraldine Collis.)

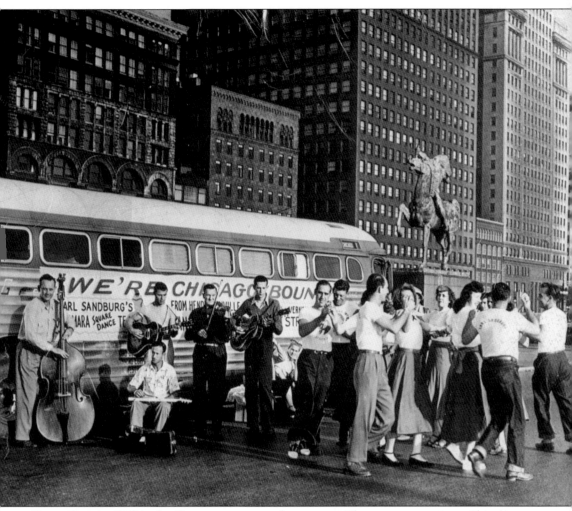

Shown here in 1948 is the Connemara square dance team. They were on a trip to Chicago to compete n the Chicago Railroad Fair. The team won the honor to compete by coming in first in the square dance competition at the Apple Festival in Hendersonville, known as the "dancingest town in America" at the time. Accompanying the team was the Vernon Rogers Blue Sky Rangers Band and David Cooley from the Hendersonville Chamber of Commerce. Traffic on the Chicago Loop stopped to watch and listen to the music. On their bus, their banner "We're Chicago Bound" is visible. (Courtesy of Geraldine Collis.)

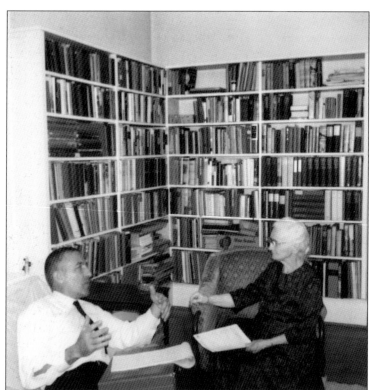

Shown at Connemara in 1967 are Secretary of the Interior Stewart Udall and Mrs. Sandburg. They were discussing plans to sell the property to the federal government. Secretary Udall brought his wife with him on the visit so they could enjoy the area and the beautiful property. The government paid Mrs. Sandburg $200,000 for Connemara, one half of its value, and the contents of the house were donated by the family. (Courtesy of Paula Steichen Polega, the Carl Sandburg Home, NHS.)

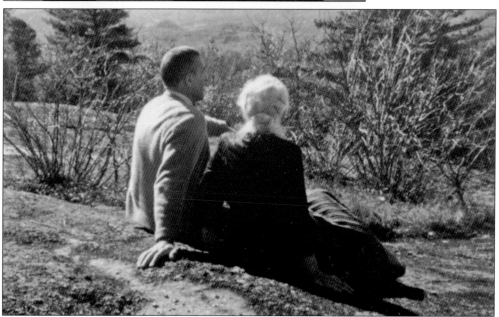

In October 1967, Lilian Sandburg led Secretary of the Interior Stewart Udall on the three-mile walk to the top of Glassy Mountain. She wanted to show him the vastness of the Connemara landscape and the "million miles of sky." She was 84 years old at the time. Udall was visiting to discuss the government's possible purchase of Connemara. (Courtesy of Paula Steichen Polega, the Carl Sandburg Home, NHS.)

Pictured here in front of the house from left to right are Sandburg's daughter Margaret; Lilian Sandburg; Carl and Lilian's first great-grandchild, Sascha, being held by his mother, Liz Steichen; John Carl Steichen, Sascha's father, who spent his early childhood at Connemara; Sandburg's granddaughter, Paula; and his daughter Janet. The occasion was little Sascha's first visit to Connemara in 1968. (Courtesy of Paula Steichen Polega, the Carl Sandburg Home, NHS.)

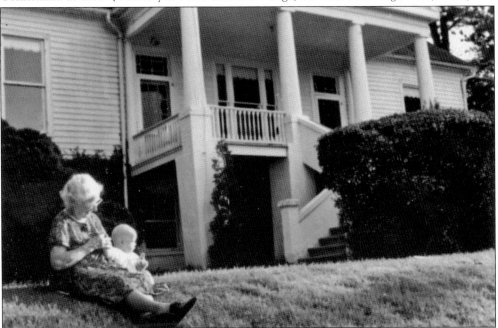

Mrs. Sandburg is shown on the front lawn playing with her great-grandson, Sascha Michael Steichen. The baby's father, John Carl Steichen, spent his early childhood at Connemara. (Courtesy of Paula Steichen Polega, the Carl Sandburg Home, NHS.)

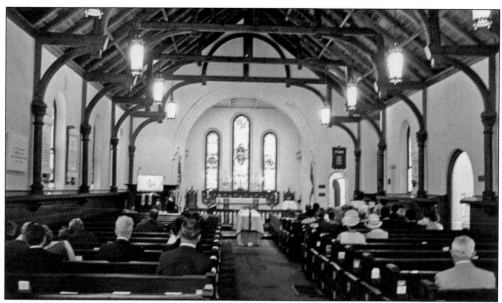

On July 22, 1967, Carl Sandburg passed away. His last word was a simple "Paula," his nickname for his wife. Although the Sandburgs were not members of St. John in the Wilderness Episcopal Church, Sandburg had requested that his funeral be held there, and the church kindly obliged. His funeral was held on July 24, 1967. The sanctuary of the church is pictured here on the day of the funeral. (Courtesy of June Glenn Jr., the Carl Sandburg Home, NHS.)

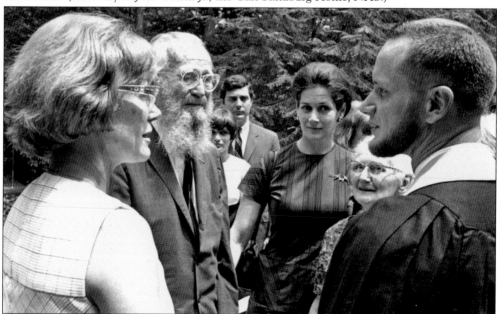

A young Unitarian minister officiated at Sandburg's funeral at the request of the family. In the service, he incorporated works by Carl Sandburg himself. The organist played "John Brown's Body" and "Shout All Over God's Heaven" as Sandburg had requested in his poem "Finish." The bell tolled once. Pictured here outside the church from left to right are Sandburg's daughter Helga; his brother-in-law, Edward Steichen; two unidentified people; Steichen's wife, Joanna; Mrs. Sandburg; and Rev. Pete Tolleson. (Courtesy of June Glenn Jr., the Carl Sandburg Home, NHS.)

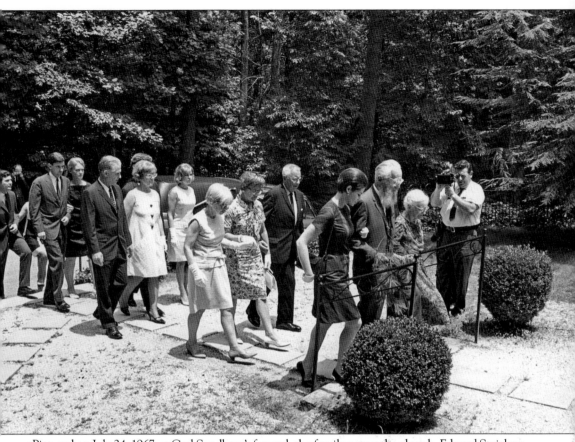

Pictured on July 24, 1967, at Carl Sandburg's funeral, the family enters the church. Edward Steichen, Sandburg's dear friend and brother-in-law, is carrying a pine bough that he had cut from a tree on the Connemara driveway. In a simple gesture, he laid the bough on Carl Sandburg's coffin. From left to right are two unidentified young men; granddaughter, Paula Steichen; Barney Crile; Helga Sandburg Crile; John Carl Steichen, partially hidden; his wife, Liz Steichen; Margaret Sandburg; Shirley Sandburg; her husband, Martin Sandburg; Joanna Steichen; Edward Steichen; Mrs. Sandburg; and an unidentified photographer. (Courtesy of June Glenn Jr., the Carl Sandburg Home, NHS.)

On January 6, 2006, in remembrance of Carl Sandburg, the National Park Service arranged for a program at St. John in the Wilderness. This is a copy of the schedule that was given to the standing-room-only crowd. The program was titled "Ring One Bell For Me."

"Ring One Bell for Me"
A Remembrance of Carl Sandburg

The Episcopal Church of St. John in the Wilderness
Flat Rock, N.C.
1:30 PM, January 5, 2006

Welcome – Rev. John Morton, St. John in the Wilderness Episcopal Church

Sandburg's birthday – Sue Bennett, Chief of Visitor Services, Carl Sandburg Home National Historic Site
- reading from "Prairie" from *Cornhuskers*

History of the St. John in the Wilderness and Connemara connection – Louise Bailey, historian

"John Brown's Body" – Howard Bakken, Organist, Carl Sandburg Home volunteer *

"A Sandburg Serendipity" – Rev. Pete Tolleson, Unitarian Universalist minister (retired)
- "Finish" from *Smoke and Steel* *
- "Personalia" from *Honey and Salt* *
- last two sections of "Timesweep" from *Honey and Salt* *

"All God's Children" – Howard Bakken, Organist *

"For You" from *Smoke and Steel* – Monk Larson and Dickie Wilson, Carl Sandburg Home volunteers and members of the Unitarian Universalist Fellowship of Hendersonville *

Sandburg Hall at the Unitarian Universalist Church of Asheville – Rev. Mark Ward, UUCA

Reception in Parish Hall

* from original Carl Sandburg funeral service

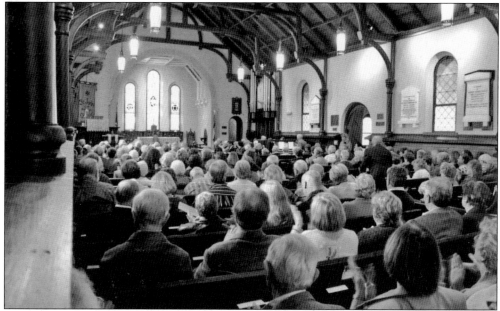

As a tribute to Carl Sandburg on the 128th anniversary of his birth, the Carl Sandburg Home and the National Park Service arranged for a celebration to be held at the same place where Sandburg's 1967 funeral was held, St. John in the Wilderness Episcopal Church. More than 230 admirers packed the historic church. Here we see the sanctuary of the church on January 5, 2006. (Courtesy of Trey Allman, *Hendersonville Times-News*.)

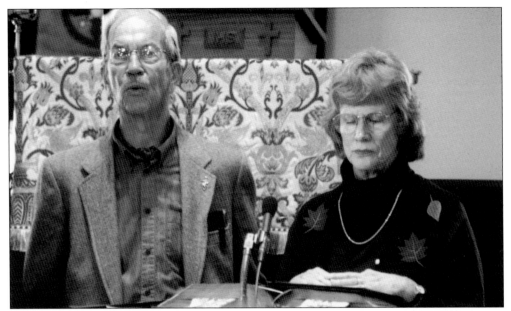

The service held at St. John in the Wilderness to honor Carl Sandburg included readings of his poetry that were included in his funeral service: "Finish" from *Smoke and Steel*, "Personalia" from *Honey and Salt*, and selections from "Timesweep" from *Honey and Salt*. From left to right are Carl Sandburg Home volunteers Monk Larson and Dickie Wilson reciting "For You" from *Smoke and Steel*. (Courtesy of Trey Allman, *Hendersonville Times-News*.)

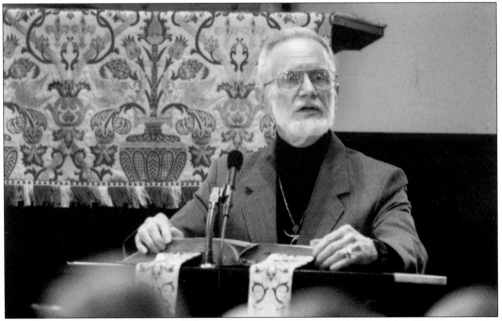

Pictured here in 2006 is Rev. Pete Tolleson, now a retired Unitarian Universalist Church minister. He officiated at Carl Sandburg's funeral in 1967. Reverend Tolleson once again presided and read from the funeral service. The Carl Sandburg Home volunteer Howard Bakken played two rousing pieces on the organ, "John Brown's Body" and "All God's Children." The church bell tolled once. (Courtesy of Trey Allman, *Hendersonville Times-News*.)

Shown in a small park behind Carl Sandburg's birthplace is Remembrance Rock. After Sandburg's death, his ashes were brought to his Illinois birthplace as requested and placed beneath the rock. Ten years later, the ashes of his wife, Lilian, were placed beside those of her husband. Remembrance Rock Park was dedicated in 1966. In 1968, Quotation Walk was created featuring stepping-stones with quotes from Sandburg's work inscribed on them. (Courtesy of the Carl Sandburg Historic Site, Galesburg, Illinois.)

Four

LILIAN SANDBURG'S CHIKAMING GOAT HERD

There is a special room at Connemara devoted to Mrs. Sandburg's work in the goat industry. The farm office contains pictures, records, files, and awards earned during her 30-plus years in the business. Lilian Steichen was born May 1, 1883, in Hancock, Michigan. She graduated from the University of Chicago in 1904. While at the University of Chicago, she studied economics, literature, German, and Latin and graduated Phi Beta Kappa, a source of great pride for her husband, Carl Sandburg, who never completed college.

Lilian Steichen joined the Socialist Party as a young woman and met Carl Sandburg at party headquarters in Milwaukee. They married six months later. From all accounts, there was, in addition to love, a deep respect in the relationship. After Carl Sandburg acquired success as a poet and biographer, the family, which then included three daughters, moved to Harbert, Michigan, on the sand dunes of Lake Michigan. It was here in 1935 that Lilian Sandburg started the Chikaming goat herd. Her involvement in goats began as a result of daughter Helga's asking for a cow as a pet. Carl Sandburg suggested goats because they would require less space and be easier to care for. The name Chikaming, Native American for "by the waters," was chosen for their goat herd, which seemed appropriate for a family living on the shores of Lake Michigan.

In addition to enjoying the taste, Mrs. Sandburg believed that goat's milk cured her gall bladder ailment. Dairy goat products soon became a permanent part of the Sandburg diet. By 1937, Mrs. Sandburg had become interested in breeding, and the herd increased until in 1944 there were close to 200 in the herd. The lack of good pasture on the Michigan property was a concern. By 1945, the Sandburgs had decided to look for a farm with ample pasture in a milder climate. Mrs. Sandburg, her daughter Helga, and sister-in-law Dana Steichen set off to find a place to suit their needs. They bought Connemara in 1945 and began the massive task of moving the herd to Flat Rock, North Carolina. Perhaps the best years for the Chikaming goat herd were the 1950s when Mrs. Sandburg's reputation as a breeder of excellent dairy goats was well established. Because of Carl Sandburg's death in July 1967 and Mrs. Sandburg's declining years, the herd was dispersed by October 1967.

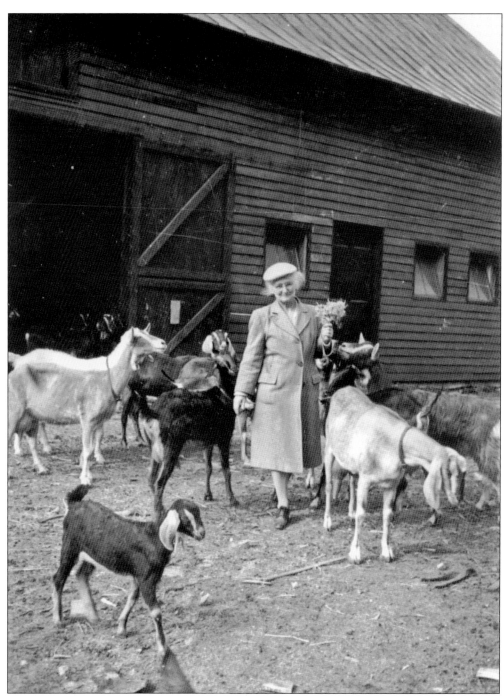

Photographed in the midst of the goat herd, Lilian Sandburg is dressed, as usual, in business-like attire. Soon after moving to Connemara, she increased the herd with the thought of beginning a commercial dairy. A milk house was built behind the barn, seen in this photograph, and for a time, the milk was distributed through dairies in Hendersonville, Asheville, and Greenville, South Carolina. (Courtesy of Paula Steichen Polega, June Glenn Jr., and the Carl Sandburg Home, NHS.)

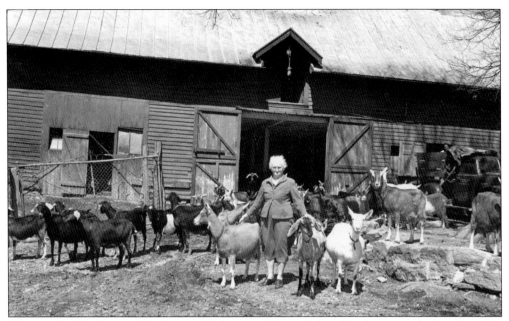

This wonderful photograph, taken in the barnyard, shows Lilian Sandburg standing in the midst of her Chikaming goat herd. In addition to managing the goat business, she was known as "Mrs. Fixit" for her ability to fix almost anything. She was an excellent businesswoman, but in addition to that quality, she really enjoyed being around her goats. (Courtesy of June Glenn Jr., the Carl Sandburg Home, NHS.)

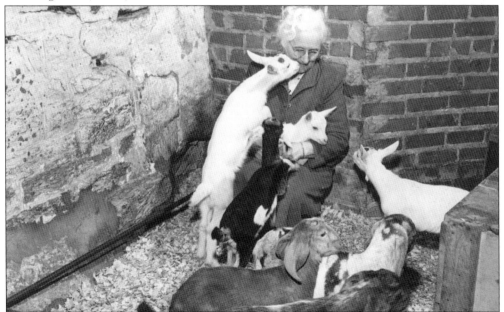

Lilian Sandburg was very much a hands-on manager of the goat herd and dairy business. She was always delighted to be around the kids. Seen here in the ground floor "kid room" of the main house, she is surrounded by Toggenburg and Nubian kids. The kids were brought into the main house for the first two to three weeks of their lives to be fed and kept warm and safe. (Courtesy of June Glenn Jr., the Carl Sandburg Home, NHS.)

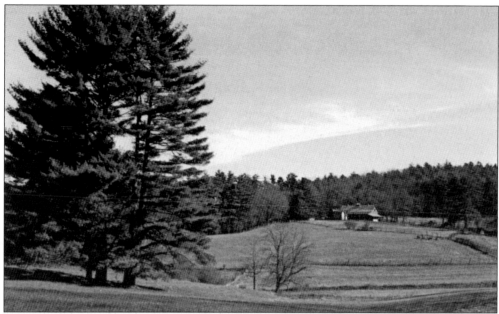

This postcard shows the extensive pasture land around the main barn at Connemara, as well as the beautiful, big evergreens. Mrs. Sandburg and her daughter Helga designed the barn layout and made plans for a milk house. They moved the first load of goats from Michigan to Flat Rock in a house trailer pulled by a station wagon. In it were bucks and does that were soon to kid. The rest of the herd was transported by truck.

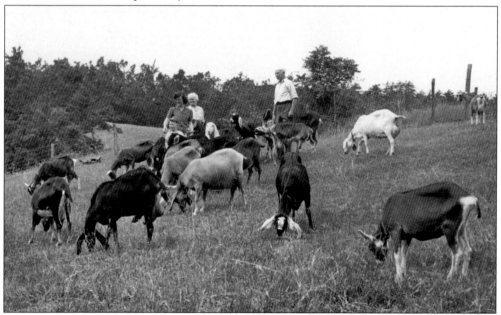

Taken in 1946, a year after they moved to Connemara, three generations of Sandburgs are pictured here visiting with the goats. After years of cold winds off Lake Michigan, their first spring in Flat Rock was a real pleasure. From left to right are John Carl, the Sandburgs' grandson; his mother, Helga; and her parents, Carl and Lilian Sandburg. (Courtesy of June Glenn Jr., the Carl Sandburg Home, NHS.)

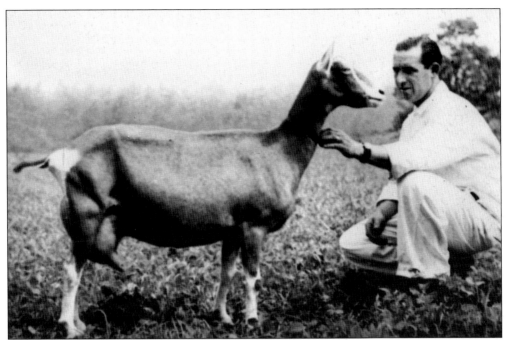

The Sandburgs' first herdsman at Connemara, Frank Mintz, is seen here with one of the prize Toggenburg does. His two children, Betty and Frankie, spent much of their childhood years at Connemara and were playmates of the Sandburg grandchildren. (Courtesy of Paula Steichen Polega, the Carl Sandburg Home, NHS.)

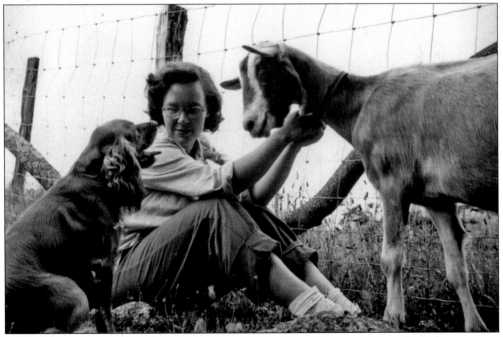

Helga is pictured here with her dog, Jackson, and a Toggenburg goat, Brenda. Helga was very much involved with responsibilities of the farm and caring for the goat herd. (Courtesy of Paula Steichen Polega, the Carl Sandburg Home, NHS.)

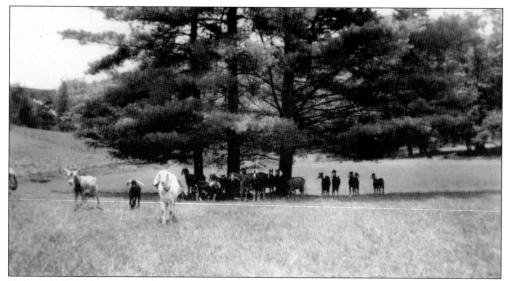

Helga filled Connemara with animals. At one time, there were not only goats, but also flocks of sheep, Black Angus cows, hogs, and hens. She also put ducks in a pond. The spreading pine boughs offered shelter for the goats from the summer sun. Mrs. Sandburg said she bought Connemara for the 100-foot pines and the ivy-covered stone walls, while Helga was charmed by the gently sloping fields and trees. (Courtesy of Paula Steichen Polega, the Carl Sandburg Home, NHS.)

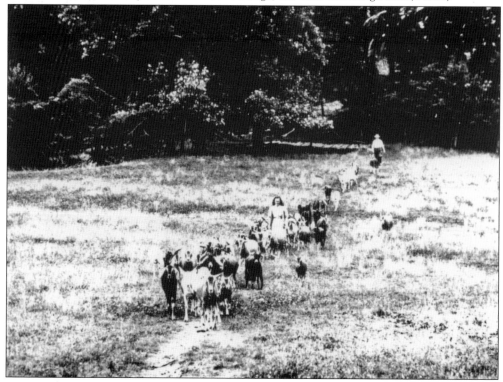

At the end of the day, the goats are seen coming in for milking. Helga is seen walking in the midst of the herd with an unidentified person at the rear. (Courtesy of Paula Steichen Polega, the Carl Sandburg Home, NHS.)

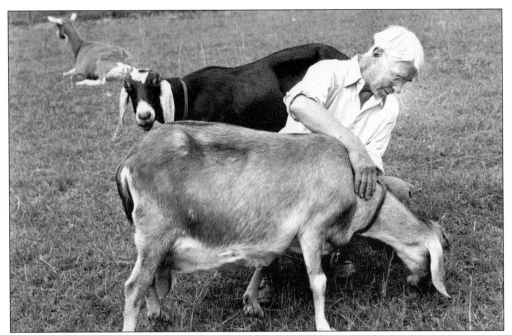

Although Carl Sandburg was not involved in the business of raising goats, he was always interested and enjoyed being around them. When he was photographed, he frequently was asked to pose with one of the dogs, but he would always insist on posing with the goats instead. Here he is seen in 1946 in the goat pasture. (Courtesy of June Glenn Jr., the Carl Sandburg Home, NHS.)

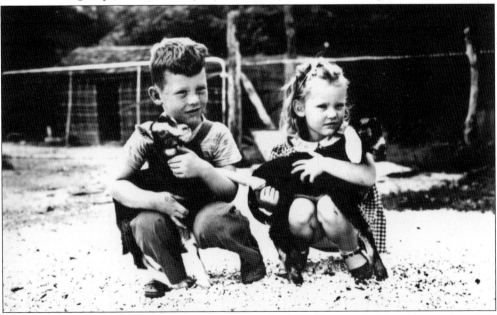

Baby goats, kids, are a real delight as playmates. John Carl (left) is seen holding a Toggenburg kid, and his sister, Paula, is seen holding a Nubian kid. Mrs. Sandburg often said that one couldn't be blue for long while around the kids. The names for the kids were chosen as they were born, thoughtful of their inheritance. The does of each family of goats had names beginning with the same letter of the alphabet. (Courtesy of Paula Steichen Polega, the Carl Sandburg Home, NHS.)

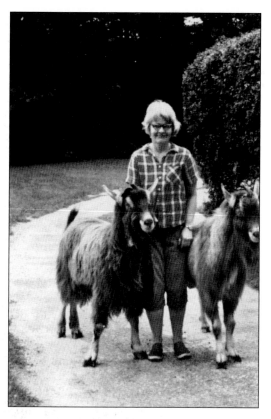

Although these bucks are an impressive size, they were very good-natured. This is a photograph of Janet Sandburg moving a pair of bucks from one pasture to another. One of Janet's duties was to feed the kids, and when they saw her coming, they would all bleat in unison. She would pour sweet food in their troughs and heat their milk. They loved the milk and drank in delight. (Courtesy of Paula Steichen Polega, the Carl Sandburg Home, NHS.)

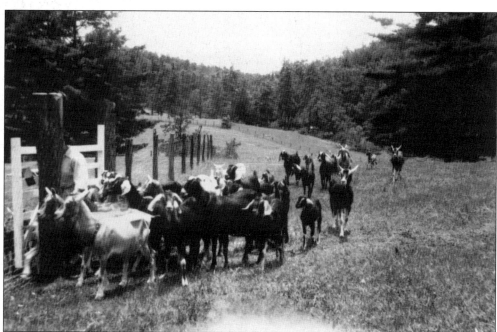

Here is another view of the pasture and the herd. Helga, partially hidden, leads the goats in for milking. (Courtesy of Paula Steichen Polega, the Carl Sandburg Home, NHS.)

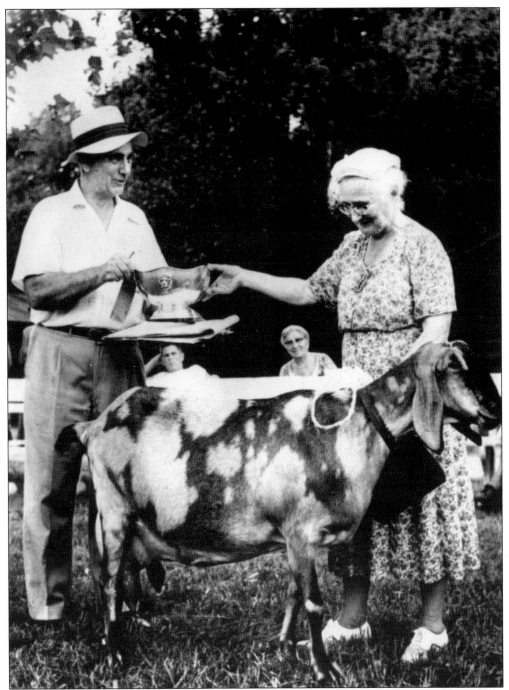

This is a favorite photograph showing Lilian Sandburg receiving the Best Nubian Udder trophy in 1957 from Col. Frank J. Vida. Although all the goats were pets, Brocade was one of Mrs. Sandburg's favorites. Brocade won first-place awards at the Western Carolinas Dairy Goat Association show every year from 1954, when she was one year old, to 1959, and Best of Breed in 1956, 1957, and 1959, making her permanent grand champion. She gave birth to 29 kids in 9 years. (Courtesy of Paula Steichen Polega, the Carl Sandburg Home, NHS.)

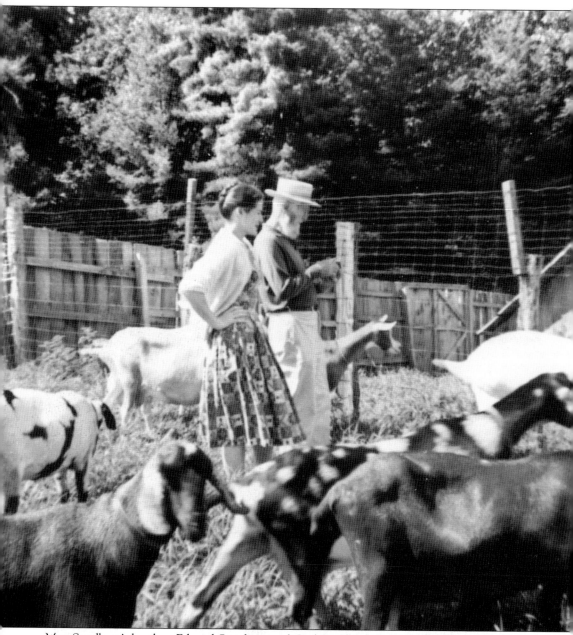

Mrs. Sandburg's brother, Edward Steichen, and Carl Sandburg formed a fast friendship almost upon meeting, and Steichen often visited Connemara. In 1961, Steichen and his wife, Joanna, were visiting and took a stroll in the barnyard. (Courtesy of Paula Steichen Polega, the Carl Sandburg Home, NHS.)

Lilian Sandburg made the walk to the barn every morning, rain or shine, snow or ice. This photograph is a favorite, as it seems to say something of her determination and strong will. She always dressed in street clothes, the type of dress she would wear to town or to go shopping. (Courtesy of Paula Steichen Polega, the Carl Sandburg Home, NHS.)

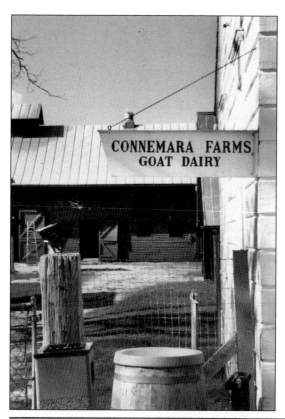

These two photographs show the Connemara Farms Goat Dairy and the main barn as they look today. The herd, descendants of the Chikaming herd, is always an attraction to visitors, especially in the spring when there are bound to be newborn kids. (Courtesy of Alice Soder.)

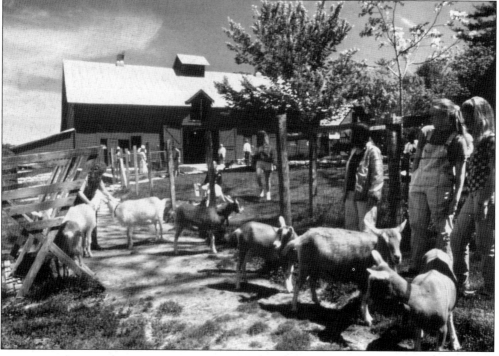

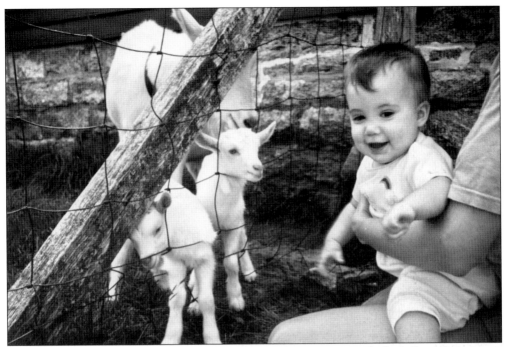

In 1989, Lu Ann Welter, above, brought her baby, Megan, to visit with the kids at Connemara. The children were brought to the park every year in the spring. Seen below, from left to right, are Shelby Welter (left) and her sister, Megan, in 1994. The park is truly a wonderful place for children to learn about animals and to appreciate nature. (Courtesy of Mrs. James Welter.)

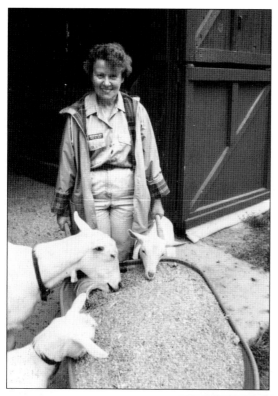

Shown in this photograph is an unidentified park volunteer bringing feed to the goats. There are many varieties of jobs for volunteers at Connemara, all interesting and worthwhile. Children from the National Historic Site volunteer program are selected each year to show the kid goats at the North Carolina State Fair. The program was established in 1990 in collaboration with the Friends of Carl Sandburg at Connemara and 4-H Agricultural Extension Service Program in Henderson County. (Courtesy of Phil Smith, the Carl Sandburg Home, NHS.)

There is nothing as charming as kittens, puppies, and baby goats. This little fellow looks like he's about to go on an exploration of the barnyard. (Courtesy of Phil Smith, the Carl Sandburg Home, NHS.)

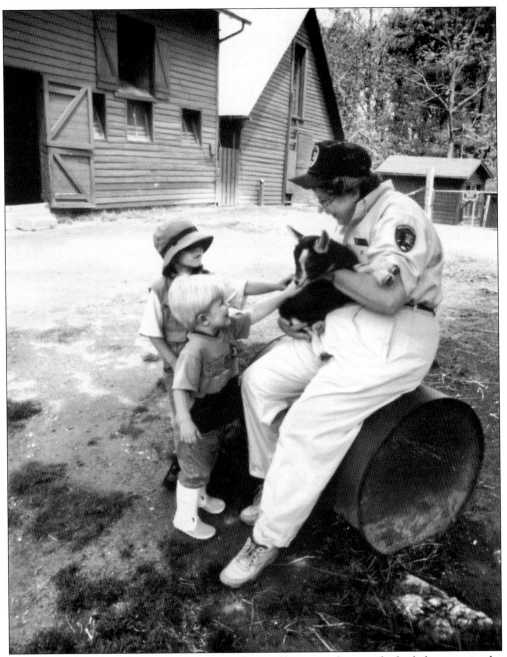

Dottie Jacobs, a park volunteer of long standing, is shown working with the baby goats in the barnyard. Children are fascinated with the kids, and Dottie is experienced and knowledgeable enough to keep their interest. The children are unidentified, but the little boy is wearing really cute little "duck" boots. (Courtesy of Phil Smith, the Carl Sandburg Home, NHS.)

To close this chapter on Mrs. Sandburg's Chikaming goat herd is a recent photograph of the main barn complex (above) and a recent photograph of two wonderful little goats cuddling to keep warm (below). Every child should be exposed to these wonderful creatures, and the National Park Service makes it so very easy at Connemara. (Courtesy of Alice Soder.)

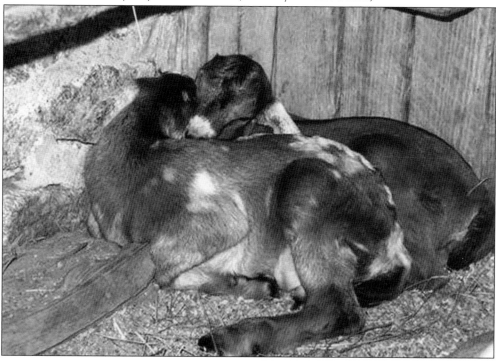

Five

IF THESE WALLS COULD TALK

From its inception, Connemara has fascinated all who visit. Built on the side of Glassy Mountain, it is an impressive house built in the Greek-Revival style. It seems to say, "I have stories to tell. I'm solid and true, and I'll be here forever."

The house overlooks a lake built by C. G. Memminger in 1855, formed by the creation of a dam on a rushing stream. There have been a variety of alterations and additions throughout the years, but the core of the house remains surprisingly the same. The house was built in 1838–1839 with interior changes made around 1848. According to a recent study, changes were made by the Greggs in the late Victorian era. They included a bay window, installation of front steps, and late-19th-century mantels. Around 1910, Captain Smyth removed the wooden steps at the front of the house and replaced them with concrete steps. The newel posts were kept and placed on either side of the drive where it splits to go around the house. In 1924, Captain Smyth replaced Memminger's addition and renovated the interior for his family's year-round use. The Sandburgs made the last major alterations when they purchased the property in 1945 and adapted the house and outbuildings for their use as their home, offices, and goat farm.

In chapter two, the living room and library interiors are shown as they looked when the Smyths called it home. Today the house contains over 12,000 books that belonged to Carl Sandburg, three-quarters of his archival materials. The balance of these materials had been sold to the University of Illinois in the mid-1950s.

The owners of Connemara have all been influential men of their time, but it was Lilian Sandburg who decided to preserve not only her husband's legacy but also their wonderful Connemara. The National Park Service took control of the property, and it became a National Historic Site. The house, barns, visitor center, grounds, and hiking trails are all open to the public. There are interpretive programs, poetry readings, plays, and children's programs all provided by park employees, volunteers, and Eastern National employees. The park is also included in efforts to conserve natural and historic resources. The assistance of volunteers is essential to continued preservation and use of the park.

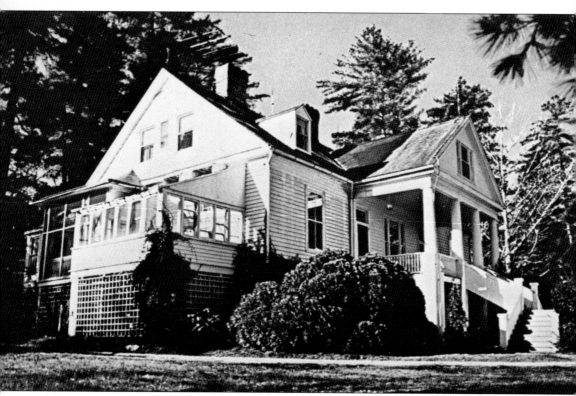

Seen on this postcard is the main house at Connemara during the Sandburg era. In addition to the house and barns, there is the Memminger Trail, a National Recreation Trail, as well as Spring Trail, both of which take walkers up Big Glassy Mountain. Both trails are 1.3 miles long. The Sandburg family often took walks on these trails and others to enjoy the flowers, shrubs, trees, and views.

Seen in this photograph is the wash house or chicken house. It was built by C. G. Memminger to house his cook and other servants. According to his papers, it was built by two of his servants, probably slaves, named Ben and Peter. In the Smyth era, one end contained two laundry basins, while the other end quartered servants. In Sandburg's time, the left side of the house as we look at it was used to house chickens, while the other side was used to house toddler goats. This was where the kids were kept after they were nurtured in the house for the first two to three weeks of their lives. Looking closely, the outside run to the right side of the house that leads up to the door was for the kids' access and egress. On the far right of the photograph, a corner of the garage that originally served as the kitchen house is visible. (Courtesy of Paula Steichen Polega, the Carl Sandburg Home, NHS.)

The ice house was built by C. G. Memminger c. 1847. A slate roof covered a 20-foot-deep, rock-lined pit. Ice was cut from the lakes in winter and then stored here, covered with sawdust, until it was needed to keep perishables from spoiling. The ice house was taken down by the Sandburgs in the 1960s. The circular underground portion of the building is still apparent on the landscape. (Courtesy of Paula Steichen Polega, the Carl Sandburg Home, NHS.)

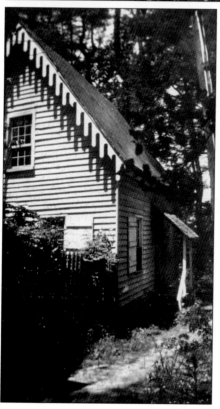

Above and at left are photographs of the Swedish house taken about 1960. It was built by C. G. Memminger in the early 1850s and served as slave quarters. As Memminger's family grew, the need for more space arose. The main house was enlarged, and the four-bedroom Swedish house was constructed. It likely provided plenty of space for slaves. Memminger thought highly of his servants and treated them well. In a letter to his wife from Germany, he sends his love to her and the children and his best regards to the servants. (Courtesy of Paula Steichen Polega, the Carl Sandburg Home, NHS, and Memminger papers, UNC.)

Pictured here is the summer house or gazebo located adjacent to an herb and flower garden. It was used for storage of garden tools. (Courtesy of Paula Steichen Polega, the Carl Sandburg Home, NHS.)

Seen peeking into the spring house/cheese house are Sandburg grandchildren Paula (left) and her brother, John Carl. When there was surplus milk, Helga and Mrs. Sandburg made cheeses here. The cheeses were a special favorite of Mrs. Sandburg's. She wrote articles for newspapers and magazines on methods of making Brie and Neufchatel-type cheeses. The little house carried scents of anise and caraway, used in making soft goat cheese. (Courtesy of Paula Steichen Polega, the Carl Sandburg Home, NHS.)

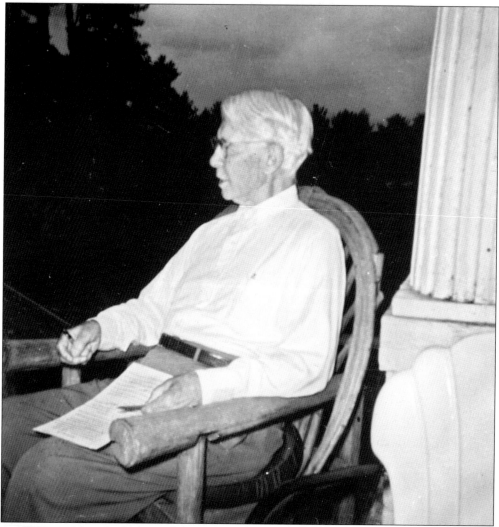

At all times of day, the front porch at Connemara beckoned. Photographed here in the evening hours is Carl Sandburg in a favorite chair. Award-winning documentary filmmaker Paul Bonesteel, who grew up in Flat Rock and visited Connemara often, is now in the funding process and pre-production phase of his documentary *Sandburg: For the People*, a film about Sandburg's life. (Courtesy of Paula Steichen Polega, the Carl Sandburg Home, NHS.)

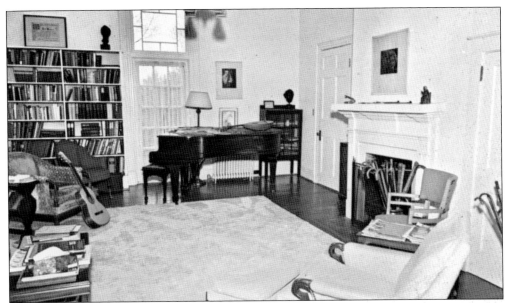

Seen on a postcard is the front room at Connemara. The picture was most likely taken around 1974. The NHS has kept contents as they were when the Sandburgs lived there. On the left, leaning against a chair, is Sandburg's guitar, exhibited in that spot for 20 years. It suffered from exposure and humidity changes. Now, thanks to the generosity of the Friends of Carl Sandburg at Connemara, visitors will see a 1940s-vintage, Spanish guitar that is typical of Sandburg's instrument. The original underwent conservation and is in climate-controlled storage for preservation.

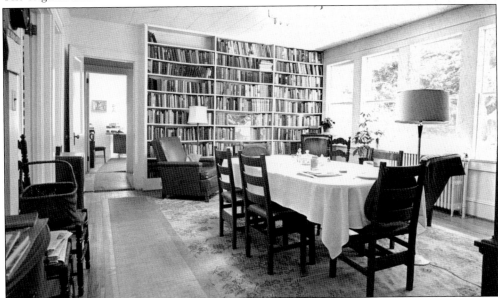

Through the glass doors of the farm office is the family dining room. This is where the Sandburg family spent most of their together time. At the far ends are floor-to-ceiling bookshelves. Carl Sandburg often took books from these shelves and brought them to the table to be read aloud during dinner. At the back of the room is a wall of windows affording views to the back of the house and the many bird feeders kept there. (Courtesy of June Glenn Jr., the Carl Sandburg Home, NHS.)

Seen on this postcard is Carl Sandburg's bedroom. It has been kept as it was when occupied by the great author and poet. It is a simple room adjoining his upstairs workroom. Sandburg often worked well into the night and didn't go downstairs until midday. When he awoke, he would play classical music on a record player in his room, often a recording by his friend Andrés Segovia.

Pictured is Mrs. Sandburg's bedroom as it was when she occupied the room. It's a simply furnished room with many windows. The walls are white and furnishings are plain and useful. She liked to keep African violets on the windowsill. (Courtesy of June Glenn Jr., the Carl Sandburg Home, NHS.)

Some of Sandburg's friends suggested he give up the guitar, but he really enjoyed singing folk songs and playing guitar at just about any venue. Here he is photographed in formal attire entertaining his audience. (Courtesy of the Carl Sandburg Home, NHS.)

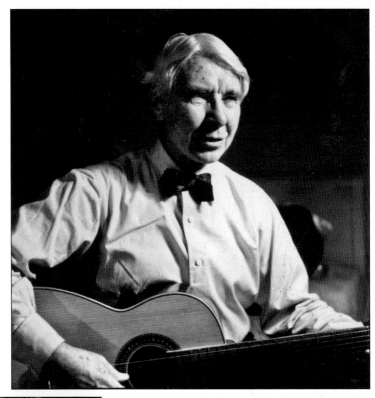

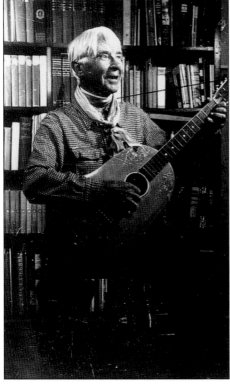

Sandburg loved folk songs, having collected them from his time riding the rails as a hobo. He published his collection in *The American Songbag* in 1927 and in *The New American Songbag* in 1950. Here he is pictured entertaining with his guitar and songs and appearing very happy to be doing so. (Courtesy of the Carl Sandburg Home, NHS.)

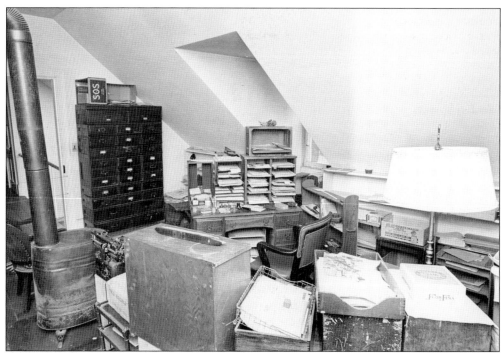

Carl Sandburg's upstairs workroom was adjacent to his bedroom. He could come and go and work into the night without disturbing the rest of the family. Here are two views of his workroom. Wherever he worked, there were mounds of books, papers, and files. He often used orange crates in place of desks or tables. He also enjoyed smoking a cigar when he worked. (Courtesy of June Glenn Jr., the Carl Sandburg Home, NHS.)

The porch at Connemara was both a place for socializing and conducting business. Here we see Hollywood producer George Stevens on the left with Carl Sandburg. This photograph was taken in June 1960. One couldn't visit Connemara without some involvement with the baby goats. Here two of the kids have hopped into the men's laps. (Courtesy of June Glenn Jr., the Carl Sandburg Home, NHS.)

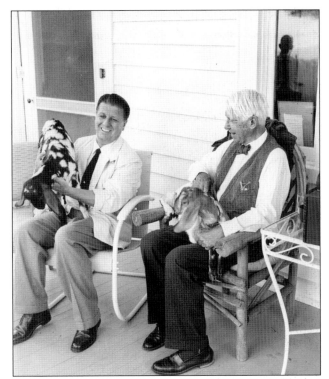

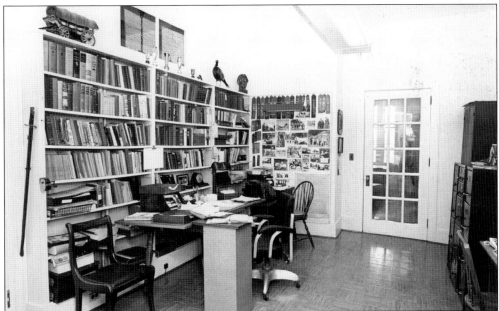

The farm office is in the center of the house and was the center of activity at Sandburg's Connemara. It was from this office that Lilian Sandburg ran the goat business and dairy. She kept meticulous files and records on each animal in the herd and did extensive research on genetics and breeding. Here she also kept awards the goats won and pictures of many of her favorites. The family dining room is reached through the French door at the far end of the office. (Courtesy June Glenn Jr., the Carl Sandburg Home, NHS.)

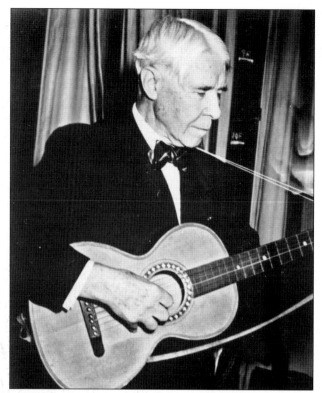

Two more photographs of Carl Sandburg playing guitar are shown here. Singing folk songs and playing the guitar were an enjoyable part of Sandburg's life. In the photograph at left, we see him entertaining in an unidentified location, perhaps after a lecture, and below he is shown relaxed and playing guitar in Mrs. Sandburg's bedroom at Connemara. (Above: Courtesy of the Carl Sandburg Home, NHS; below: Courtesy of June Glenn Jr., the Carl Sandburg Home, NHS.)

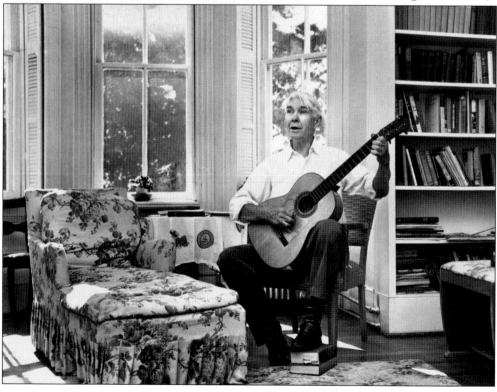

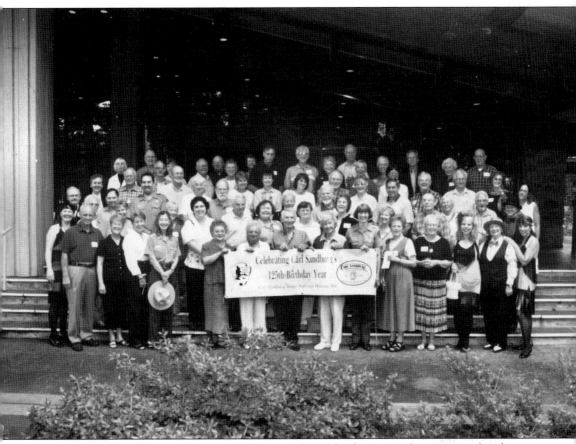

The Carl Sandburg Home volunteers are shown gathered for their annual recognition luncheon. In 2004, the Sandburg Volunteer Program was recognized as the best in the National Park Service Southeast Region. The first volunteer program was with the museum operation to help with conservation. The Rover program, whose duties are to walk the trails and make contact with the public who use the trails for recreational purposes, began in 2000. They also make sure the trails are kept clean. The Barn volunteers serve four-hour shifts, morning and afternoon. They clean and feed the goats and make contact with the public. (Courtesy of Connie Hudson Backlund, park superintendent, the Carl Sandburg Home, NHS.)

"Home is where the heart is...."

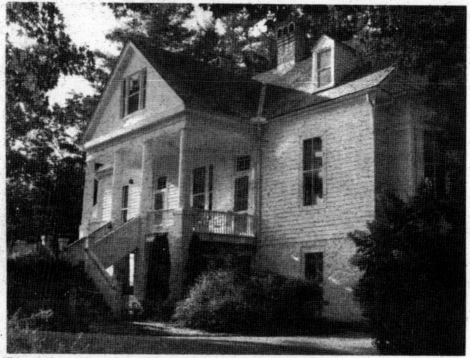

Photo Courtesy of Jeffrey B. Miller, MountainLens.com

Friends of Carl Sandburg at Connemara

Shown is a brochure for the Friends of Carl Sandburg at Connemara. Friends, as it is called, is an independent, nonprofit organization that provides financial and volunteer support for the Carl Sandburg Home, the grounds, and educational programs. Particular attention is focused on programs for children. The Friends of Carl Sandburg at Connemara welcomes individual memberships.

In these two recent photographs, the Carl Sandburg Home main house, where tours are conducted by both volunteers and Park Service employees, is visible. (Courtesy of Phil Smith, the Carl Sandburg Home, NHS.)

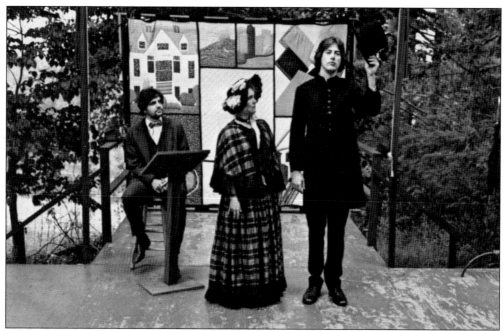

On this postcard is a photograph of actors performing a historical drama based on Carl Sandburg's *Abraham Lincoln: The Prairie Years*. It is being performed on site at Connemara. This is just one of many such performances scheduled during the year, many of which are performed by actors from the Flat Rock Playhouse. All are entertaining and educational.

In this photograph, the contact station or welcome area that is located near the parking lot can be seen. It exhibits many photographs of Carl Sandburg and quotations from his work. From here, visitors can walk up to the main house and barns, or for those who require transportation, it can be summoned from this area. (Courtesy of Alice Soder.)

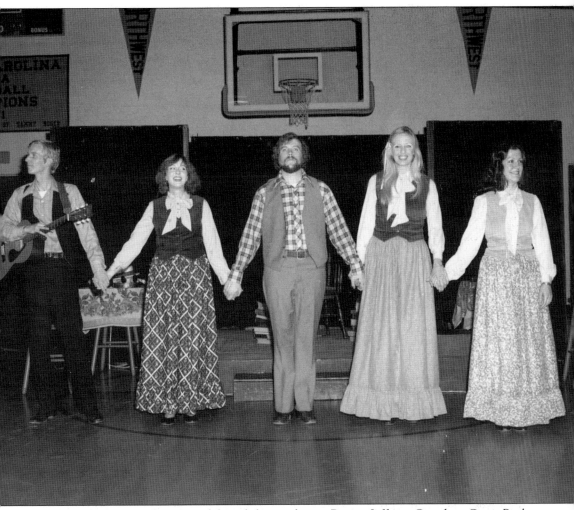

In this 1978 photograph, pictured from left to right are Bowen Jeffries, Gretchen Genz, Paul Wilson, Diane Disque, and Karen Furno. Beginning in 1968, the Vagabond Players of the Flat Rock Playhouse toured North Carolina and performed *The World of Carl Sandburg* in public schools. The play is a tribute to Sandburg and contains selections from his works. These performances were extremely well received, were of high educational value to high-school students, and helped them gain an appreciation of Sandburg's works. (Courtesy of the Flat Rock Playhouse.)

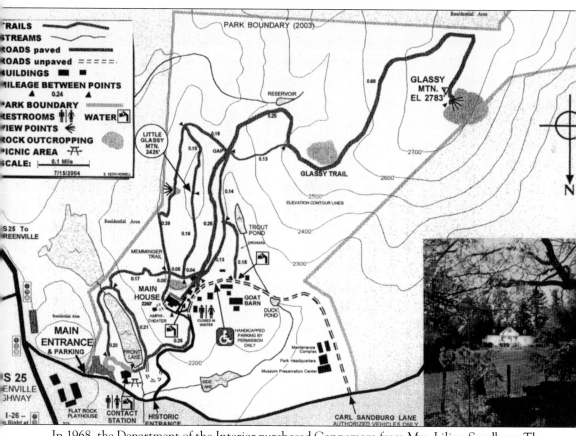

In 1968, the Department of the Interior purchased Connemara from Mrs. Lilian Sandburg. The park is pictured on this map, which outlines not only buildings on the property but the extensive trails and parking facilities. The park contains 264 acres.

In this 2005 photograph, unidentified actors from the Flat Rock Playhouse apprentice program are pictured performing *The World of Carl Sandburg* at Connemara. The play was designed as a tribute to Sandburg and his vision of America's possibilities and is composed of selections from his works. (Courtesy of Michael McCracken, the Flat Rock Playhouse.)

The Carl Sandburg Home has an excellent relationship with its neighbor, the Flat Rock Playhouse, located across Little River Road from the park. Apprentices from the playhouse are seen in this photograph performing *The World of Carl Sandburg*. From left to right are Cory Mitchell, Tara Sisson (kneeling), Katie Barton, and Bailey Poteet. (Courtesy of Michael McCracken, the Flat Rock Playhouse.)

When Georgia Bonesteel moved to Flat Rock with her family in 1972, she became a volunteer at Connemara, where she worked in Sandburg's upstairs workroom and catalogued material. She came up with the idea of a quilt to serve as a backdrop for outdoor presentations. Well known as a quilter, author, and television show host, she designed the quilt and gathered other quilters to join her in the project. Seen above is Georgia Bonesteel at the presentation of the quilt. Below is a close-up of the quilt showing the design. Quilters who worked on the project in addition to Bonesteel are Joan Flanagan, Bonnie Garren, Jack Gibson, Nester Harbin, J. Jay Joannides, Laurie Johnson, Jeannette Ledbetter, Sara Meadows, Maude Mills, Audrey McManus, Marion Pardee, Georgianna Payton, Eric Williams, Cathy Willis, Laurie Wolff, and Marian Tinsley. (Courtesy of Georgia Bonesteel.)

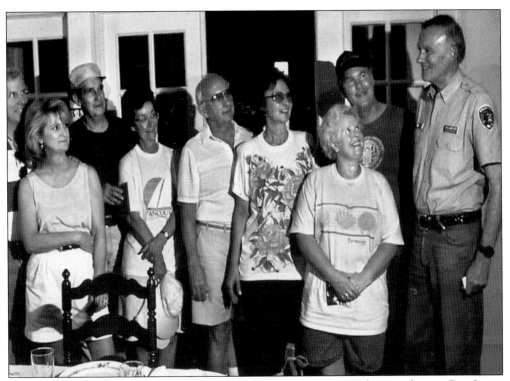

Pictured here are two of the Carl Sandburg Home volunteers. Above is house volunteer Don Lavin about to lead a tour group in the main house. The tours last for 30 minutes. Below is Ed Ormsby, who is a barn volunteer. (Courtesy of Phil Smith, the Carl Sandburg Home, NHS.)

Two volunteers at the Carl Sandburg Home are seen in these recent photographs. At left is Susan Jones working as a barn volunteer, and below is Jim Stockman, who is a museum volunteer. He's shown preserving coal grates. (Courtesy of Phil Smith, the Carl Sandburg Home, NHS.)

This is a photograph of Barbara McGraw, education volunteer at the Carl Sandburg Home. She is leading a group of middle-school children on an educational tour of the park. (Courtesy of Phil Smith, the Carl Sandburg Home, NHS.)

Pictured here are Connie Hudson Backlund (left), superintendent of the Carl Sandburg Home National Historic Site, and Mary Satterfield, then-president of the Friends of Carl Sandburg at Connemara. They are about to cut the cake celebrating Carl Sandburg's 125th birthday year. (Courtesy of Connie Hudson Backlund, park superintendent, the Carl Sandburg Home, NHS.)

ACROSS AMERICA, PEOPLE ARE DISCOVERING SOMETHING WONDERFUL. *THEIR HERITAGE.*

Arcadia Publishing is the leading local history publisher in the United States. With more than 3,000 titles in print and hundreds of new titles released every year, Arcadia has extensive specialized experience chronicling the history of communities and celebrating America's hidden stories, bringing to life the people, places, and events from the past. To discover the history of other communities across the nation, please visit:

www.arcadiapublishing.com

Customized search tools allow you to find regional history books about the town where you grew up, the cities where your friends and family live, the town where your parents met, or even that retirement spot you've been dreaming about.